IMAGES
of America

WINSLOW

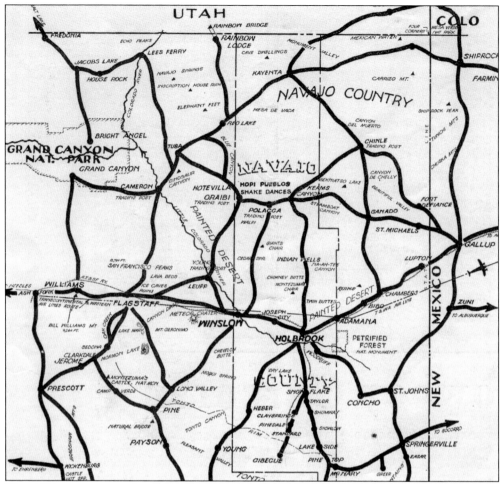

This 1930 tourism map shows Winslow at the hub of a transportation and tourism crossroads. The Santa Fe Railway's last grand hotel, La Posada, opened there that year because of Winslow's proximity to Meteor Crater, Hopi and Navajo tribal lands, and the Petrified Forest National Monument. The recently-designated US Route 66 (seen here running from Gallup, New Mexico, to Ash Fork, Arizona) brought businesses and travelers to downtown Winslow until Interstate 40 bypassed it in 1979. Winslow's new Charles Lindbergh–planned airport was one of 12 key stops on Transcontinental & Western Air's coast-to-coast passenger route. (Courtesy of the Old Trails Museum Archives.)

ON THE COVER: The Santa Fe All-Indian Band posed in front of La Posada Hotel after a 1948 concert honoring General Motors' *Train of Tomorrow* locomotive. The intertribal group, which consisted of Santa Fe Railway employees and family members, formed in 1923 and performed at a wide range of civic functions over the next 41 years. (Courtesy of the Old Trails Museum Archives.)

IMAGES
of America

WINSLOW

Ann-Mary J. Lutzick, Winslow Historical Society,
and the Old Trails Museum Archives

ARCADIA
PUBLISHING

Published by Arcadia Publishing
Charleston, South Carolina

Printed in the United States of America

Library of Congress Control Number: 2013932838

For all general information, please contact Arcadia Publishing:
Telephone 843-853-2070
Fax 843-853-0044
E-mail sales@arcadiapublishing.com
For customer service and orders:
Toll-Free 1-888-313-2665

Visit us on the Internet at www.arcadiapublishing.com

To the people of Winslow,
who have lived, preserved, and shared the city's fascinating history.

Contents

ACKNOWLEDGMENTS

I would first like to thank each former director of the Old Trails Museum, as well as past and present boards of directors and members of the Winslow Historical Society. Their tireless efforts over many years of collecting, researching, and preserving the images and documents that tell Winslow's story constitute the substance of this book.

Former directors Janice Griffith and Lila Atkins conducted research for projects ranging from the museum's annual historical calendars to its collections on the Arizona Memory Project. Journalist Janice Henling interviewed residents and wrote a series of articles for Winslow's centennial that ran in the *Winslow Mail*. Vada Carlson Rodriquez's books *Snapshots* and *A Town Is Born: A Pictorial Review of Winslow, Arizona's First Fifty Years* (the latter coauthored with her husband, Joseph Cruz Rodriguez) provided another rich resource. I am also grateful to Dr. Rosa Archibeque Sheets for allowing me access to her work in progress, tentatively titled *The History of Chicanos in Winslow, Arizona: 1885–1975*, and for editing a draft of this book. Most recently, the Winslow Centennial Committee researched and presented Second Saturdays in Winslow, a series of local historical programs honoring Arizona's state centennial in 2012.

Other sources included Thomas Sheridan's *Arizona: A History (Revised Edition)*, Stephen Fried's *Appetite for America*, Arnold Berke's *Mary Colter: Architect of the Southwest*, Joe Soderman's *Route 66 in Arizona*, *Feasibility Study for the Little Colorado River Valley National Heritage Area* by Archaeology Southwest (formerly the Center for Desert Archaeology), and online articles published by the National Park Service.

I received vital assistance and feedback from David Andreasen, Erik Berg, Janice Griffith, Bob Hall, Curtis Hardy, David Hartman, Janice Henling, Marie LaMar, Michael J. Lawson, and Bill Shumway. Thanks also to the various individuals and institutional staff members who loaned their wonderful images, and to my editor at Arcadia, Stacia Bannerman, for her guidance and patience. Lastly, I want to thank my husband, artist and longtime museum supporter Daniel Lutzick. He encourages and supports me in every aspect of my life, and this book was no exception.

Unless otherwise noted, all images appear courtesy of the Old Trails Museum Archives.

INTRODUCTION

Winslow is a railroad town. Founded in 1880 by the Atlantic and Pacific Railroad (A&P), Winslow sits in the high desert of the southwestern Colorado Plateau and within the watershed of the Little Colorado River. The Colorado Plateau is a huge basin filled with smaller plateaus that spreads across northern Arizona, southeastern Utah, southwestern Colorado, and northwestern New Mexico. A tributary of the mighty Colorado River, the Little Colorado flows erratically with winter snowmelt and summer monsoons, and the area only receives 10 to 13 inches of precipitation a year.

Despite the harsh terrain and climate, the A&P laid out the Winslow townsite along its new transcontinental line through northeastern Arizona Territory precisely because the Little Colorado and its tributaries supplied a vital water source. The watershed had previously sustained the nearby Homol'ovi (a Hopi word meaning "place of small buttes") villages of the Ancestral Puebloans, and a passable ford across the river brought prehistoric trails, scientific expeditions, pioneer wagon roads, and Mormon settlers through the area long before the railroad arrived. But the railroad is not all there is to the history of this small town of almost 10,000 people.

Anthropologists maintain that the area's earliest inhabitants were Paleo-Indians who hunted Columbian mammoth, gathered wild foods, and used stone tools between 10000 and 5500 B.C. Agriculture developed during the Archaic period, from 8000 to 1000 B.C., which allowed for substantial population growth. Ancestral Puebloans, ancestors of the Hopi, inhabited the area from A.D. 200 through 1600. Climate disruptions marked this long span of Puebloan history, as did advancements in hunting strategies, agricultural methods, ceremonial and living spaces, and pottery techniques and styles. They developed complex economic, religious, and social systems in a challenging natural environment.

The Homol'ovi villages just northeast of present-day Winslow were at peak activity in the 1300s. Inhabitants mastered techniques for growing corn in the high desert, and they likely grew and traded cotton for pottery with the Pueblo villages on the mesas to the north. When they vacated their villages at the end of the 14th century, it is believed that Homol'ovi's inhabitants migrated north to the mesas along the Palatkwapi Trail. The land they left behind now constitutes Homolovi State Park, and the federal government established the Hopi Reservation to the north in 1882.

The Athabaskans, hunter-gatherer ancestors of the Navajo, may have arrived in the Southwest as early as the 1400s from northern Canada. By the 1700s, Navajos, or Diné (a Navajo word meaning "the people"), were building wooden homes called hogans, growing crops, tending sheep, and engaging in mutual trade with Pueblo people and others living on the Colorado Plateau. Relatively little European activity occurred there prior to the mid-1800s. Francisco Vázquez de Coronado's 1540–1542 expedition for Spain had failed to find the region's fabled Seven Cities of Cíbola, and Pueblo people resisted the conversion efforts of Franciscan missionaries in the mid-1600s. Though the Spanish introduced new crops, horses, and sheep to the region and beyond, neither Spain nor Mexico ever gained control of Arizona's portion of the Colorado Plateau.

The United States acquired all or part of 10 future states as a result of the Mexican-American War and subsequent 1848 Treaty of Guadalupe Hidalgo, and the region's Mexican nationals

automatically became American citizens. The federal government created the New Mexico Territory in 1850 and established Fort Defiance the following year in the heart of Navajo lands. Pres. Abraham Lincoln created a separate Arizona Territory from the New Mexico tract in 1863, but the region remained relatively isolated and undeveloped. Military posts like Fort Defiance consumed most of the territory's crops and livestock, and soldiers received additional supplies from traveling operators driving oxen and mule.

In the winter of 1864, the federal government forced nearly 9,000 Navajos on the "Long Walk" (Hweéldi in the Navajo language) to desolate Fort Sumner at Bosque Redondo in New Mexico. Over 2,500 died from starvation and exposure on the journey, and more died from the deplorable conditions at the fort. When the survivors returned from their imprisonment four years later, they stopped at Fort Defiance on their way to the newly established Navajo Reservation to pick up thousands of sheep and goats provided by the federal government for resettlement. The largest tribal entity in the United States in both area and population, the Navajo Nation straddles parts of Arizona, Utah, and New Mexico, bordering Winslow to the north. Both Hopi and Navajo people have continually migrated between their tribal lands and Winslow, which the Navajo call Béésh Sinil ("place of steel rails"), for trade, employment, education, and public services.

Businessmen had been calling for a transcontinental railroad since the 1840s, so the federal government began sending military expeditions to map potential east-west routes across the nation's western lands. In 1853, Lt. Amiel W. Whipple charted a railroad route along the 35th parallel that crossed the Colorado Plateau; he also recommended the development of a wagon road along the same route. In 1857, Lt. Edward F. Beale was sent to establish such a road, which traversed the Little Colorado River at Sunset Crossing and continued through the future townsite of Winslow. A popular pioneer trail during the 1860s and 1870s, the Beale Wagon Road became the base corridor for the future railroad, US Route 66, and Interstate 40.

The first settlers of European origin in the Winslow area were members of the Church of Jesus Christ of Latter Day Saints, better known by the name of their sacred text, the Book of Mormon. Led west by Brigham Young in 1847, church elders soon sent out missionaries from their new home in Salt Lake City to establish settlements throughout the Southwest. John Doyle Lee was sent to develop a strategic crossing at the junction of the Colorado and Paria Rivers in 1871, and Lee's Ferry later became a key link in the Mormon Wagon Road that connected the Utah and Arizona Territories. The road and its branches were later nicknamed the "Mormon Honeymoon Trail" because many betrothed pioneers traveled it to the temple in St. George, Utah, to have their marriages sealed before they went on or returned to Arizona Territory. After he was executed for his involvement in the 1857 Mountain Meadows Massacre, Lee's 17th bride, Emma Louise Bachelder Lee, married prospector Franklin H. French. They moved to Winslow, and she became the trusted healer and midwife known as "Doctor Grandma French."

In 1876, Young sent a wagon train of over 200 men, women, and children on the Mormon Wagon Road to establish settlements along the Little Colorado River—the first ones in Arizona Territory. Avoiding the Little Colorado's treacherous quicksand on the bedrock of Sunset Crossing, they set up the Brigham City and Sunset camps close by, and the Joseph City and Obed camps closer to present-day Holbrook. Brigham City, just one mile north of present-day Winslow, was a protective fort with eight-foot sandstone walls, living quarters, a kitchen, dining room, school, blacksmith, cellar, well, and facilities for making soap, pottery, and leather. Outside the walls were a gristmill, livestock corrals, and wheat fields. Nearby Sunset boasted the first post office on the Little Colorado.

Hopis and Navajos had warned the settlers about the unpredictable river, and floods repeatedly washed out their fields and irrigation dams. Drought, labor shortages, and dissensions over the United Order, a cooperative system in which land and goods were held in common, also contributed to the failure of three of the four communities. The Brigham City settlers were released from their calling in 1881 and moved to other Mormon settlements in the territory. Though most of the fort walls were later moved to the west grounds of La Posada Hotel, members of Winslow's

Mormon Church are currently restoring Brigham City, and historic Sunset Cemetery is preserved within Homolovi State Park.

It was the railroad that ultimately drove settlement in northern Arizona Territory. Congress made public lands available for railroad development through the series of Pacific Railroad Acts passed from 1862 to 1866, but the Civil War temporarily interrupted industrial development in the West. The first transcontinental railroad began operating from Omaha to Sacramento in 1869, and Pres. Andrew Johnson chartered the A&P Railroad to build another cross-country line along the 35th parallel. Congress also granted the railroad 40 sections of land through several states and territories in 1866, but the A&P went into receivership in 1875 without completing its task. The St. Louis & San Francisco Railway (the Frisco) formed the following year to take over the troubled A&P.

Cyrus K. Holliday formed what was ultimately named the Atchison, Topeka & Santa Fe Railway in 1859. Known as "the Santa Fe," the railroad had evolved into a major rail line by the time it entered into the Tripartite Agreement with the Frisco in 1880. As a result, a joint board of trustees controlled A&P stock and oversaw the development of the 35th parallel line. Now a subsidiary of the Santa Fe, the A&P established a Western division that ran from south of Albuquerque to Needles, California. A&P track gangs laid out a new townsite just west of Sunset Crossing and south of Brigham City in December 1880, choosing the location because of the available water from nearby Clear Creek. Not only would the steam engines get the fresh water they required every 100 miles, the ample water supply would also accommodate a major A&P division point. The new town was named in honor of former Union general and president of the Frisco, Edward F. Winslow. The first rail line arrived from Albuquerque in December 1881.

The Santa Fe bought the A&P in 1897, and Winslow began a period of sustained growth prompted by the transfer of the railroad's division headquarters from Gallup, New Mexico, and the subsequent influx of employees. Winslow transformed from a railroad boomtown to a major city along the principal rail line to the West Coast, with its location as a livestock, trade goods, and lumber shipping point contributing to its growth and stability. Its proximity to natural and cultural sites and its orientation as a transportation corridor also made it an ideal tourism destination. Fred Harvey established Winslow's first Harvey House in 1887 and opened La Posada, the last Santa Fe grand railroad hotel in the Southwest, in 1930. US Route 66 ran through downtown Winslow starting in 1926, influencing the city's expansion, decline, and renewal for the rest of the 20th century and beyond. Starting in 1929, Winslow's Charles Lindbergh–planned airport was a key stop along Transcontinental Air Transport's first coast-to-coast passenger route. For all these reasons, Winslow enjoyed the largest population in northern Arizona from 1900 through the 1950s.

Winslow's growth was scuttled after World War II when the Santa Fe began to modernize operations and expand its workforce elsewhere, as well as when Interstate 40 bypassed Route 66 in 1979. Winslow's population is currently stable at almost 10,000, and the various ethnic groups are maintaining their historic percentages; approximately half the population is of European descent, one third claims a Latino heritage, one quarter is Native American, and less than 10 percent identifies as either African American or Asian American. The largest employers include the Burlington Northern & Santa Fe Railway, the Winslow Unified School District, Northland Pioneer College–Winslow Campus, the Little Colorado Medical Center, Winslow Indian Health Services, and an Arizona Department of Corrections facility south of town. As in so many rural towns in Arizona, tourism is also a growing economic factor.

This book explores Winslow's prehistory, founding, expansion, and heyday through the 1960s. The images reveal the economic, civic, community, and recreational lives of its residents over time. For a city of its size, Winslow has a rich and varied history that is still evident in local sites, buildings, and residents' memories. That history connects Winslow with the Southwest and the nation as a whole in diverse and unexpected ways.

One

A Town Is Born
Prehistory and Early Growth

Long before the Atlantic & Pacific Railroad (A&P) arrived on the Colorado Plateau, the Little Colorado River and its tributaries sustained the nearby Homol'ovi villages of the Ancestral Puebloans. A passable ford across the river known as Sunset Crossing also brought prehistoric trails, scientific expeditions, pioneer wagon roads, and Mormon settlers through what is now the Winslow area. In December 1880, A&P track gangs laid out a new townsite near the abundant water supply from Clear Creek, and the railroad designated Winslow a major division point with maintenance facilities, offices, and permanent staff. The new town was named in honor of railroad executive Edward F. Winslow, and the first rail line arrived from Albuquerque on December 3, 1881.

Tracklaying across the territory came to a halt while crews struggled to cross Canyon Diablo, a gorge in the Colorado Plateau 25 miles west of Winslow. Meanwhile, A&P workers in Winslow stayed busy with other projects. They built a pump house on the Little Colorado and rail yards that included a roundhouse, refueling facilities, machine shops, blacksmith shops, stockyards, and a depot. Col. Justus K. Breed moved into town from his trading post on the Little Colorado and erected the town's first permanent structure in 1883, a mercantile and saloon that included a post office in which mail was set out on the bar and sorted by the recipients themselves.

By 1895, Winslow's population had grown to around 900 people of European or Mexican descent. As the city began to boom with permanent residents, primarily railroad staff or employees of businesses that served them, its growth attracted enterprises typical of a Western town in the late 19th century. J.F. Wallace moved his newspaper from St. Johns to Winslow in 1887 and renamed it the *Winslow Mail* in 1894. Populated by an ethnically diverse mix of railroaders, entrepreneurs, and cowboys, Winslow was an exciting place to be as the Old West entered the 20th century.

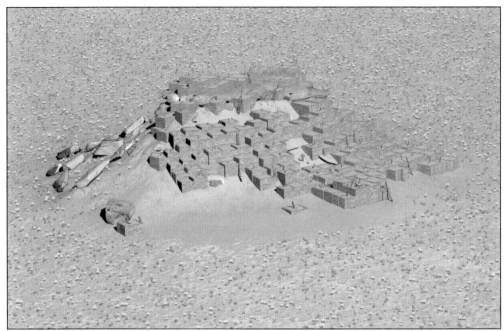

This digital reconstruction of Homol'ovi IV, a major Ancestral Puebloan village just northeast of present-day Winslow, is based on research conducted by the Homol'ovi Research Program at the Arizona State Museum. Occupied from around 1250 to 1280, Homol'ovi IV consisted of 150 rooms constructed from local sandstone. (Illustration by Douglas Gann; courtesy of Archaeology Southwest.)

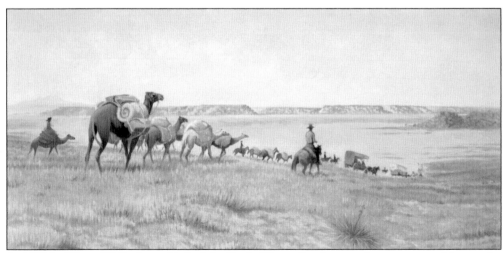

In 1857, Lt. Edward F. Beale established the Beale Wagon Road, a popular pioneer trail during the 1860s and 1870s that passed through the future townsite of Winslow. As illustrated in this painting by Winslow artist Joseph Cruz Rodriguez, Beale famously used camels during his expeditions in the semiarid West. The animals ate desert grasses and were faster and stronger than horses, but the experiment did not result in their permanent use.

Also by Joseph Cruz Rodriguez, *Tucker Flats—West of Winslow* depicts the Mormon wagon train sent from Utah Territory by Brigham Young to establish settlements along the Little Colorado River. They founded Brigham City just north of present-day Winslow in 1876. The fort's residents endured floods, drought, and labor shortages before being released from their calling in 1881 and moving to other Mormon settlements in Arizona Territory.

Another Rodriquez painting, *Sunset Crossing—East of Winslow,* shows early residents taking advantage of the underlying bedrock to cross the Little Colorado. Nearby Clear Creek supplied Winslow's steam engines and the infrastructure for a major division point, which included essential buildings and permanent personnel.

Challenged by the elements as well as by the brutal nature of the work, A&P track gangs trudged their way across the Little Colorado River Valley. Surveyors worked ahead of section crews, which included graders, tracklayers (like the ones seen here in the 1880s with a Marion steam shovel used for excavation), and "pikers" that pounded spikes through wooden ties.

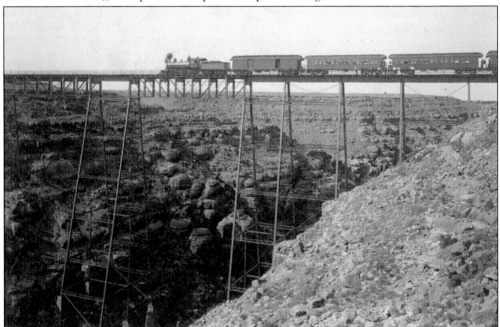

Over 200 laborers worked six months to construct the 11 iron stands that supported the single track across Canyon Diablo. A rough town of the same name—full of saloons, gambling dens, and brothels—sprang up during construction, only to disappear once the bridge was complete. Westerners considered Canyon Diablo Bridge to be one of the region's greatest feats of engineering when it opened on July 1, 1882.

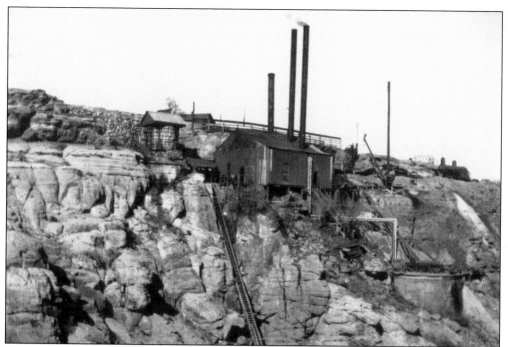

A&P workers in Winslow built a pump house along the Little Colorado River that brought water to the townsite. In 1898, the Santa Fe Railway constructed this new steam-powered pumping station at Clear Creek. It brought water to a reservoir at the canyon's edge before pumping it through a pipeline to Winslow's rail yards, six miles away.

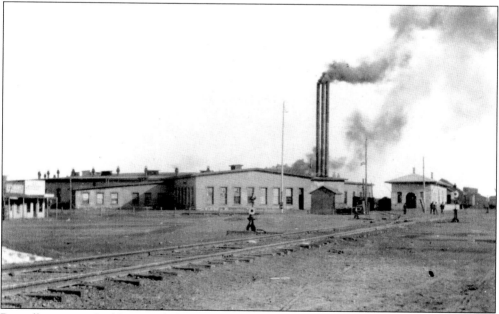

Roundhouses are buildings with large turntables that allow for inspection, repair, and storage of locomotives. Winslow's first roundhouse burned in 1895, destroying eight valuable steam locomotives and putting the A&P in financial jeopardy. This roundhouse was rebuilt on the same site, just east of present-day La Posada Hotel.

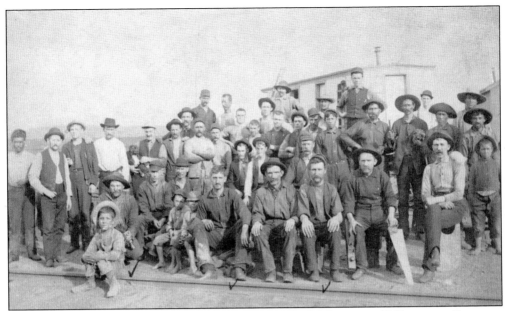

Preferring workers with previous railroad experience, the A&P recruited US citizens, European immigrants, and Mexican nationals (many of whom became naturalized American citizens). Many Navajos were also trained to work on early section crews. In 1892, these workers paused for a photograph in Winslow's rail yards.

Considered Winslow's first businessman, Frederick C. Demarest arrived in 1880 ahead of some railroad crews and erected tent "hotel" rooms as housing on Railroad Avenue. In 1885, he opened the Arizona Central Hotel, a two-story, red sandstone building with white porches and cottonwood and tamarisk trees planted in front. Demarest soon added a restaurant and saloon, and he was known for insisting on good behavior from his patrons.

Most of Winslow's early residents lived in tent houses or railroad-tie shacks. Women used small stoves for heating and cooking, and they swept out buckets of red dirt on windy days. This tent home on Aspinwall Street was made of canvas built over wood floors, with window flaps to allow breezes in or keep the cold out. The A&P later built section houses and employee cottages south of the tracks.

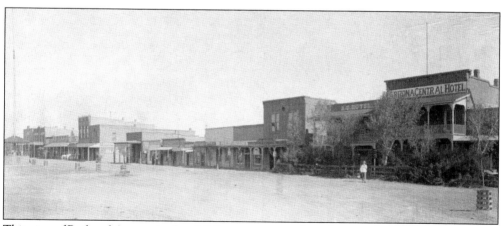

This view of Railroad Avenue is what A&P passengers saw from the train depot in 1885. Businesses along Winslow's main artery included, from left to right, the Hotel Navajo, Lesser and Sawyer's Grocery, the Ohio Restaurant, the Reception and Parlor Saloons, the Peoria Restaurant and Saloon, and the Arizona Central Hotel. Townspeople and travelers enjoyed concerts and orators from the gazebo on the far left.

Fernando Thornton "F.T." La Prade arrived from Georgia in 1886 and opened a blacksmith shop. He helped build the first dam at Clear Creek and sold barrels of water he hauled to town. La Prade purchased the Brigham City site in 1890 and built this stone barn using the fort's east wall. He established Sunset Dairy at the La Prade Ranch in 1905, which the family operated until 1955.

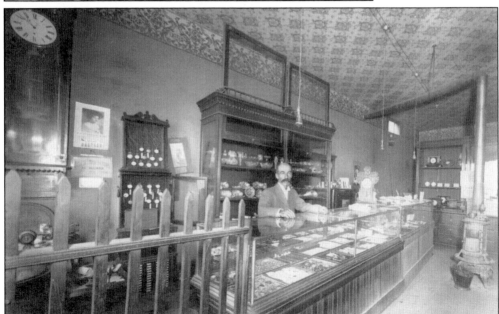

Watchmaker George F. Schaal moved to Winslow in 1897 to inspect and repair the essential timepieces of railroad workers and officials. He opened a jewelry shop on Railroad Avenue and also served as Winslow's mayor.

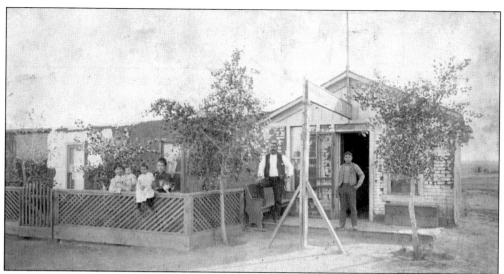

The Bacas were one of the first prominent families to live and own businesses in Southside, or "Chicana." Like many early residents of Mexican descent, Santiago and Emma Baca came from New Mexico Territory in the 1880s. He worked for the railroad, owned the Baca and Monte Carlo Saloons, and was a delegate to Arizona's Constitutional Convention. Above, in 1903, his daughter Trinadad Baca Leyva (fourth from left, with cat) and her family stand outside their home and grocery store in Coopertown, or "Palomas," located south of the tracks and west of Southside. Pictured below in 1899, the Aztec Saloon in Southside was owned by José Leyva (sixth from left, without hat).

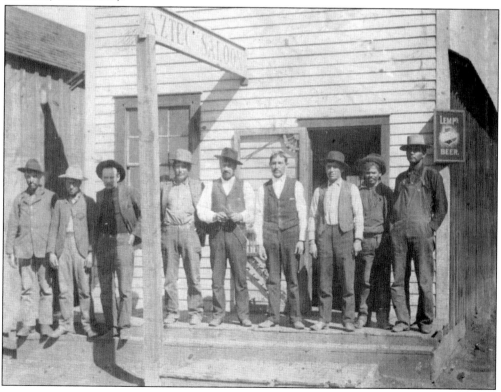

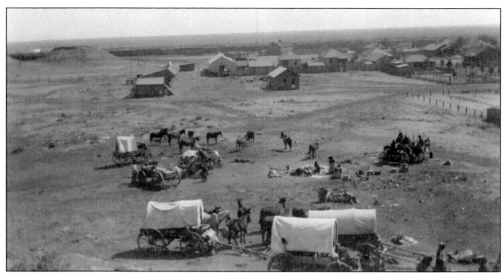

Navajos and Hopis came to town to trade at Richardson's Trading Post. They camped with their wagons at the west end of town, and local children would sometimes trade with them for rides on their horses and burros. Hopis would walk door to door to trade their white peaches for clothes and other items. (Courtesy of Arizona Historical Society, #42898.)

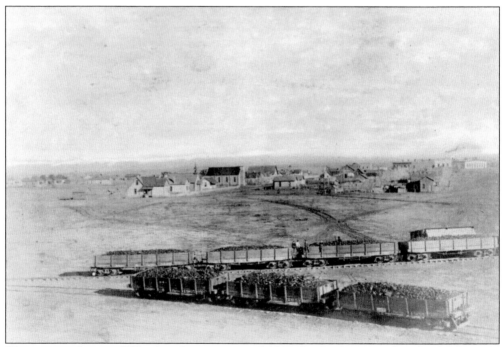

This eastward view of Winslow dates to around 1890. In the foreground is the A&P's wye, a triangular arrangement of tracks that allowed locomotives to change direction. The first roundhouse is in the distance on the right, and the street running between the buildings is now eastbound Historic Route 66/Second Street. (Courtesy of Northern Arizona University, Cline Library, Special Collections & Archives, NAU.PH.3 #220.)

Two

BOOMTOWN NO MORE
INCORPORATION AND EXPANSION

In 1897, the Atchison, Topeka & Santa Fe Railway (Santa Fe) acquired the A&P's Western Division outright and transferred division headquarters from Gallup to Winslow. The railroad boomtown blossomed into a bustling city with the subsequent influx of Santa Fe employees. A *Winslow Mail* editorial that year stated, "Winslow begins to present the appearance of an eastern town. There are more families and fewer single men."

But Navajo County, formed from the western half of Apache County in 1895, still governed the town. Holbrook served as the county seat, the county sheriff was responsible for enforcing the law, and the county board of supervisors appointed constables for each town. Meanwhile, the railroad dominated Winslow's development, controlling land sales, street maintenance, fire protection, and the water supply. Though the Santa Fe administration fought it, Winslow's growing business community pushed for incorporating the city of over 1,300 people. The Navajo County Board of Supervisors granted incorporation on January 4, 1900, and Winslow's first city elections were held in March.

By the time Arizona became the 48th state of the Union on February 14, 1912, Winslow had a population nearing 4,000. The city boasted a waterworks department, sewer system, electric company franchise, telephone lines, police and fire departments, corner streetlights, and brick crosswalks at each intersection. The 1912–1914 city council voted to renumber the streets established by the 1893 town plat. Railroad Avenue became First (or Front) Street, Third Street became Second, Second Street became Third, and First Street became Fourth. The railroad complex near the second roundhouse included a Santa Fe Reading Room, as well as a Harvey House restaurant and hotel. Referred to as "the metropolis of Northern Arizona," Winslow grew steadily until the next boom in 1926: the establishment of US Route 66 through downtown.

Mr. Morgan (left), Winslow's F.T. La Prade (center), and Mr. Ortega served as Navajo County supervisors from 1901 to 1905. La Prade was also the first Winslow resident to serve on the Apache County Board of Supervisors before Navajo County was formed. He made the 200-mile round trip to the Apache County seat of St. Johns on horseback from 1890 to 1894.

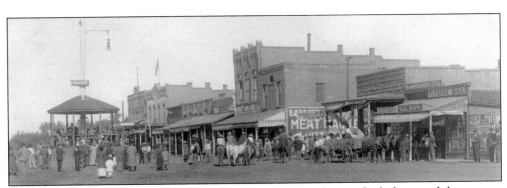

By 1912, the year of Arizona statehood, Front Street was bustling with clothing and shoe stores, tailors, barbers, laundries, drugstores, bakeries, meat markets, and multiple restaurants, hotels, boardinghouses, and saloons. Winslow boasted blacksmiths, lumberyards, coal and wood dealers, and a bottling works. Professional services were available from banks, telegraph offices, civil engineers, notary publics, real estate offices, doctors, dentists, attorneys, and a justice of the peace.

The Marley family moved to Winslow from Texas in 1904, establishing a ranch outside of town and opening the Marley Meat Market on Kinsley Avenue. They likely moved the building in this photograph from Kinsley to the lot next to their home at 406 Front Street. J.W. Marley (far right) is pictured with two of his sons.

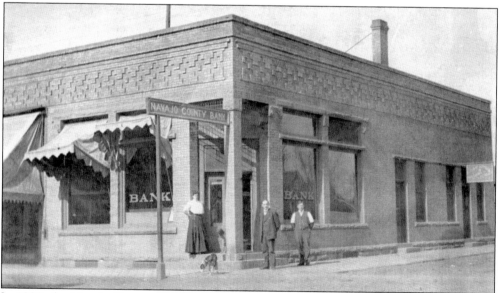

In 1900, the Navajo County Bank opened a branch in Winslow on the southwest corner of Second Street and Kinsley Avenue, seen here in 1909. The Bank of Winslow opened as the first hometown financial institution in 1904, only to close in 1924 when cattlemen were unable to repay their loans after adverse weather reduced their herds.

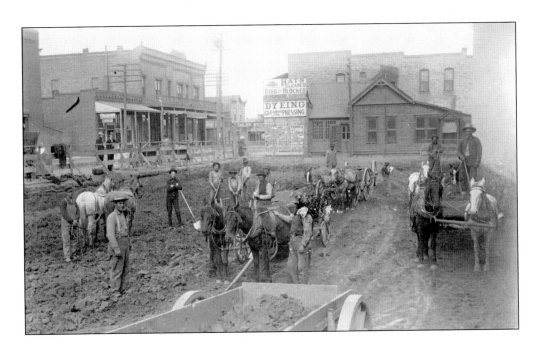

Laborers excavated the foundation for the original Elks Building on the northeast corner of Second Street and Kinsley Avenue in 1912 (above). In 1913, W.G. Kelly opened his drugstore on the first floor, and he and his partner rented out the second floor to community groups such as the Elks. The Kelley Drug Company later became Central Drug Store. Below, from left to right, Dee Trammel, Slaughter Murray, and John B. Drumm are pictured inside Central Drug around 1925. The shop featured a pharmacy, marble soda fountain, stationery, and postcards.

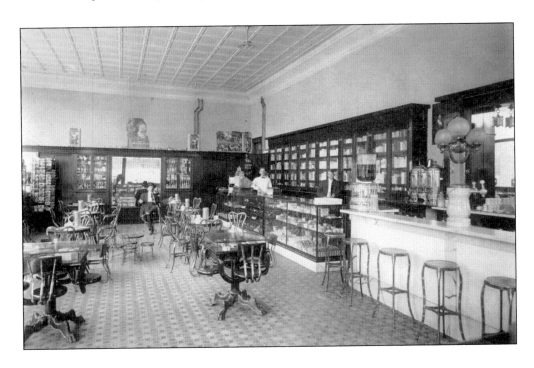

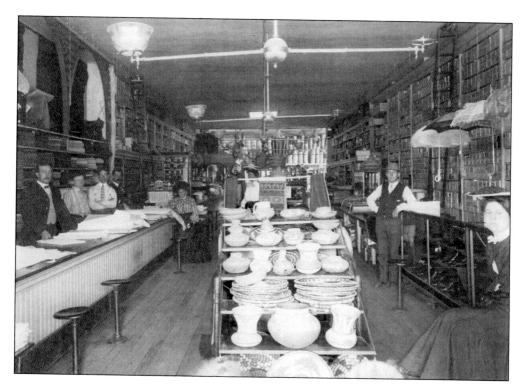

The Babbitt Brothers Mercantile Company of Flagstaff opened its first Winslow store in 1898 in the former Lesser & Sawyer's Grocery on Railroad Avenue. In the 1902 interior view above, clerk Richard M. Bruchman stands third from left. Mercantile stores were usually located in long, narrow buildings with high ceilings, and not an inch of space was wasted. Ben and Johnny Williams, sons of trading post operator Jonathan P. Williams, owned a mercantile in town prior to 1920 (below). They stocked kerosene, cooking pots, essential dry goods, and foodstuffs. (Above, courtesy of Dona Bruchman Harris.)

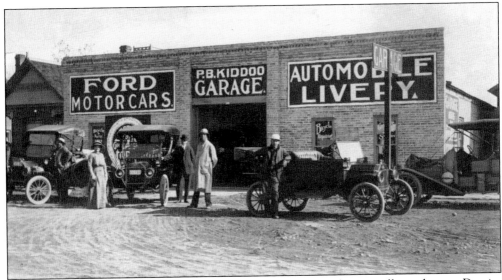

Residents were skeptical of automobiles in a region where the roads were still treacherous. Despite their doubts, P.B. Kiddoo was the proud owner of Winslow's first garage, seen here just after it opened in 1914 on West First Street. Kiddoo's greatest frustration was obtaining replacement parts, which sometimes took as long as three months.

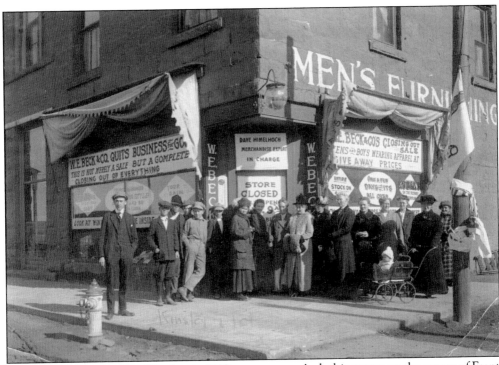

William E. Beck arrived in Winslow in 1910 to open a men's clothing store on the corner of Front Street and Kinsley Avenue. In 1916, W.E. Beck & Company held a closing sale, pictured here, so that he could move his family to Show Low, Arizona. Beck was also an amateur photographer, and his daughter Louise Beck Lancaster donated hundreds of images to the Old Trails Museum.

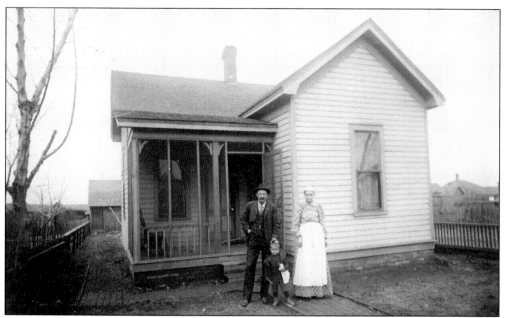

Winslow's high winds, noisy rail and stock yards, and constant roar of steam engines may have been a shock to new residents coming from more established towns. Despite the rough environment, strong and adaptable women maintained households, raised children, and improved their communities. Above, from left to right, Barnett "Barney" Stiles, Zearl Stiles, and relative Caroline Benton stand outside their home on Warren Avenue in 1904. Below is the Demarest home on West Third Street, with Martha "Ma" Demarest second from left and Frederick C. Demarest on the far right. Higher-income residents built brick houses north of the tracks on lots they purchased from the Santa Fe.

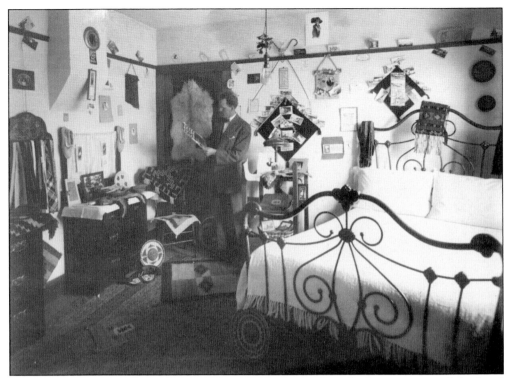

In this 1910 photograph, bachelor William E. Beck stands in his room at one of the local boardinghouses, surrounded by postcards, family portraits, and his prized Hopi baskets and Navajo blankets. Beck and schoolteacher Mary Lee married in 1911 and had two children before moving to Show Low in 1916.

As life in town eased, people found time for recreation. William Colbert Norman signed on to the Santa Fe in 1886 and worked as a locomotive engineer in Albuquerque until he and his wife, Lettie, moved to East Third Street in 1907. He loved to race his prize trotters at the racetrack north of town; here he is taking one of them out for a ride in 1912.

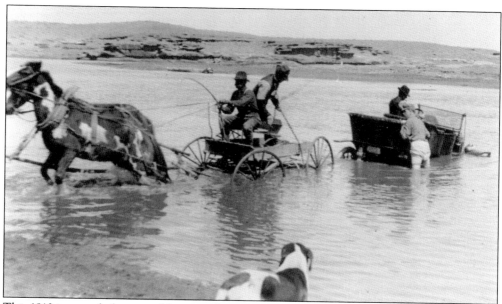

This 1910 image of a horse-and-buggy pulling a Model T from the Little Colorado illustrates the difficulty people had navigating this unpredictable river. The Santa Fe built a railroad bridge over the best bedrock in the riverbed, and several Winslow families lost members to flash floods and quicksand while trying to cross elsewhere.

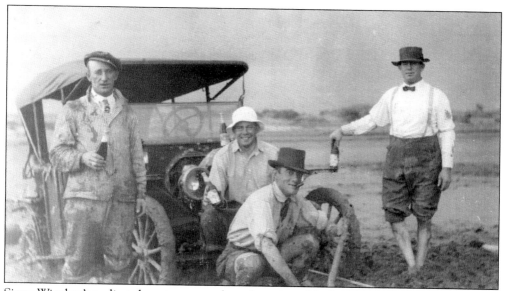

Since Winslow's earliest days, townspeople and tourists alike have visited nearby tribal lands. Pictured here, from left to right, David Figg, Gus Hansen, Joseph Le Chance, and Bill Kelly began a three-day trip with their wives and some friends to visit the Hopi mesas in 1915. They got stuck en route for four days and were rescued by Navajos, who pulled the vehicles out of the mud with their ponies.

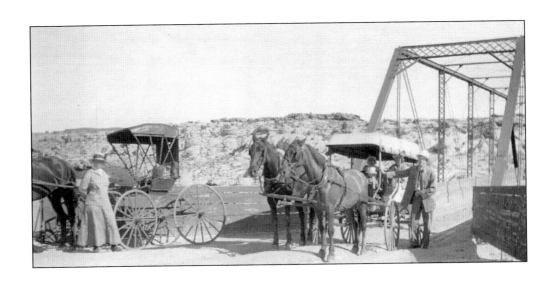

Built in 1910, the Clear Creek Bridge (above) made it easier for Winslow residents to travel to Holbrook and back. Early recreational activities included swimming at Clear Creek (below), picnics, hayrides, scavenger hunts, and dances. Children played kick the can and sandlot baseball, roller-skated on the few cement sidewalks, sledded down Kinsley Avenue when it snowed, and hunted for red "rubies" (garnets) on Ruby Hill on the east side of town. Families enjoyed taffy pulls, watermelon busts, and making jam with wild grapes from Jack's Canyon, south of town.

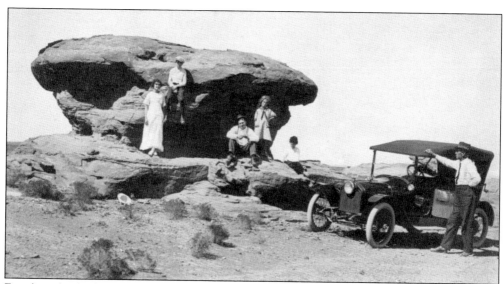

Families also had outings and picnics at the Devil's Punchbowl, a distinctive rock formation southeast of town. Local contractor, undertaker, and politician William A. Parr (far right) drove a group there in 1914 in his Briscoe. Elected to the territorial senate in 1894, Parr helped create Arizona's progressive-era constitution when it achieved statehood in 1912.

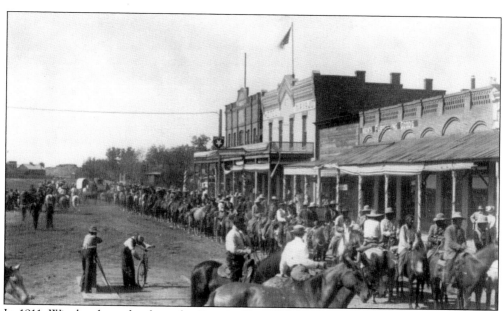

In 1911, Winslow hosted a three-day Frontier Days Celebration and invited the entire Arizona Territory. Over 1,000 visitors from as far away as Tucson flooded the town, including these 600 Navajos on horseback parading down Railroad Avenue. The celebration included Indian dances, band performances, contests, and a large frontier ball. Letters and telegrams poured in the following week congratulating the community on its hard work and success.

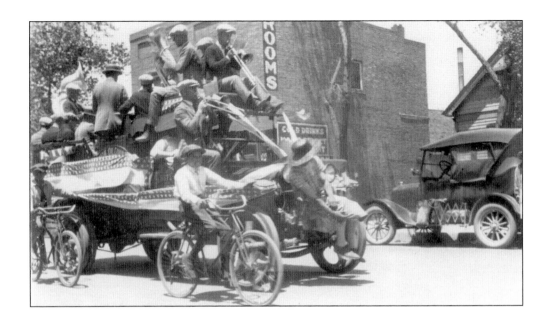

The truckload of musicians participating in a 1920s Fourth of July parade down Second Street (above) illustrates the shift of the city's center from Front/First Street to the parallel street directly north of it. By 1920, Second Street was part of the National Old Trails Highway, which was on the verge of becoming a stretch of US Route 66. Businesses on the north side of the street (below, left) included Kelly Drug, the Palace Hotel, Cahn General Mercantile, the federal post office, the Electric Theater, the Palace of Sweets, Sunset Dairy Depot, the Old Trails Garage, and Holmes Supply. Businesses on the south side included the Downs Hotel, the American Chop House, Mickey's Chinese Restaurant, and Café California.

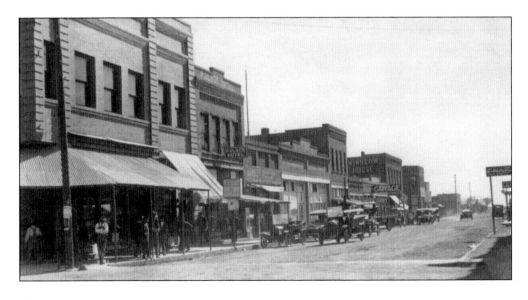

Three

LIFE ALONG THE LINE
THE ATCHISON, TOPEKA
& SANTA FE RAILWAY

In 1859, Cyrus K. Holliday formed what was ultimately named the Atchison, Topeka & Santa Fe Railway. Better known as the Santa Fe, it bought the A&P's Western Division between Isleta, New Mexico, and Needles, California, in 1897 and immediately transferred division headquarters from Gallup to Winslow. The influx of infrastructure and employees gave Winslow stability, and railroading dominated the lives of most residents during the first half of the 20th century.

The Santa Fe began running diesel freight locomotives in 1941 and chose Winslow as a servicing point. After World War II, Santa Fe and city officials discussed expanding Winslow's diesel shops. But town leaders resisted further population growth, so the railroad moved its diesel service to Barstow, California. Santa Fe passenger trains were completely dieselized by 1954, and freight trains were dieselized by 1959.

The Santa Fe still employed over 1,000 people, more than any other business in town. By 1960, up to 30 freight trains and 14 passenger trains a day still changed crews in Winslow. But technological advances that streamlined operations resulted in lost jobs throughout the railroad industry. Facing competition from the airlines, the Santa Fe also shed its less profitable passenger service and focused on hauling freight. In 1971, Congress authorized Amtrak to provide passenger service nationally, and its *Southwest Chief* still stops twice a day at La Posada Hotel.

Closed to guests in 1957, the La Posada building functioned as the Albuquerque Division headquarters starting in 1963. In 1995, the Interstate Commerce Commission approved the merger of the Santa Fe with the Burlington Northern Railroad. Winslow served as division headquarters for the A&P from its arrival in 1881, for the Santa Fe from 1897 to 1995, and, finally, for the Burlington Northern and Santa Fe (BNSF) from 1995 to 2001, when it moved its headquarters to Belen, New Mexico. Even though the BNSF is one of the largest employers in town, Winslow is no longer dependent upon the railroad. As with many small towns and cities in Arizona, its future depends on diversifying its economic base.

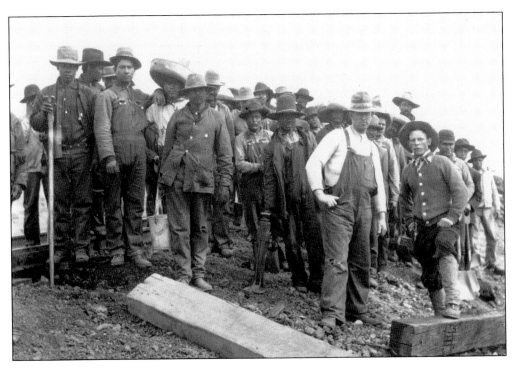

The Santa Fe needed strong laborers to maintain tracks and bridges along the line. Above, Ed Conway's crew is seen repairing the tracks at Penzance, east of Holbrook, in 1911. Below, this section crew works to lay double tracks between Winslow and Williams in 1938 (the Santa Fe had started such work on parts of the line in 1922). Local section workers often lived south of the tracks in one-room row houses with gas heaters. (Above, courtesy of the Conway family; below, courtesy of Ernest Martinez.)

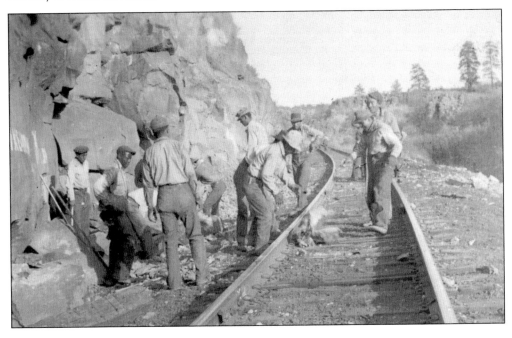

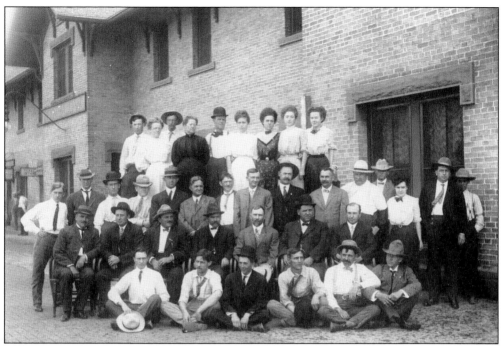

Groups of Santa Fe workers gathered for annual photographs. These staff members posed in front of the Albuquerque Division office in the Harvey House in 1908. The Santa Fe identified everyone by name and position, including the supervisors seated in the second row, from left to right: superintendant E.J. Gibson, district trainmaster E.H. Duffield, general foreman V.C. Procter, and division engineer E.E. Ball. Other employees include dispatchers, operators, wire chiefs, clerks, stenographers, accountants, draftsmen, agents, and messengers.

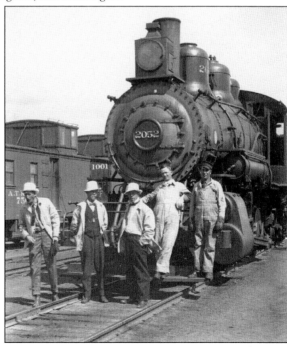

This switch engine crew posed in Winslow's rail yards in 1912. They are, from left to right, Harry Donalson, Tom McGinnis, Eddie Caroll, Ray Lancaster, and Bill Vanderbeck. Originally, there was only a single track, so when one train needed to pass another, the lesser train pulled onto a siding and waited. Passenger trains had priority over freight trains.

Above, members of the 1926 roundhouse office staff pose in front of the building. More than 450 men worked in the roundhouse in 1929 (below), where three eight-hour, around-the-clock shifts a day were needed to keep engines and boxcars in working order. Roundhouse workers, who had to shout or use hand signals because of the great noise and bustle, included machinists, boilermakers (welders), and coal-chute and water-tank workers. Master mechanics approved final inspections before engines were rotated on the turntable and returned to the tracks by hostlers (yard engineers). Yard clerks wrote down the contents, weight, and destination of each boxcar, which were recorded in conductors' books. Telegraphers gave written train orders to section foremen, who held them up attached to wooden hoops that conductors grabbed as the trains passed.

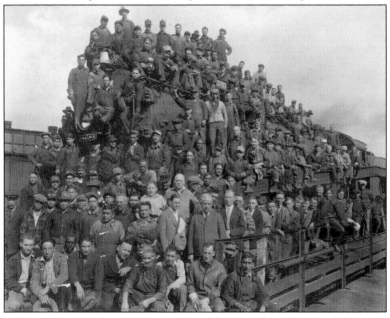

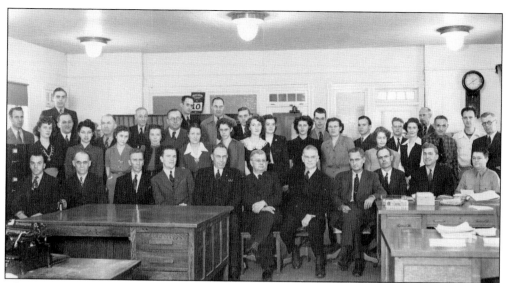

Above, the Albuquerque Division office clerks had their photograph taken in 1943; chief clerk H.C. Kabelin is seated fifth from the right. Trainmen like the ones seen below in 1930 worked as conductors, engineers, firemen, and brakemen. They worked two days on and one day off and could be called to work anytime, day or night. They had to be clean-shaven and in a suit and tie when reporting to the roundhouse, where they changed into overalls, hats, and neckerchiefs that protected them from hot cinders. Conductors reported to the yards for freight and passenger information, assigned speeds, and numbers of stops. Engineers operated the steam engines, firemen fed coal or oil to steam boilers, and brakemen looked for trouble as they walked the tops of cars.

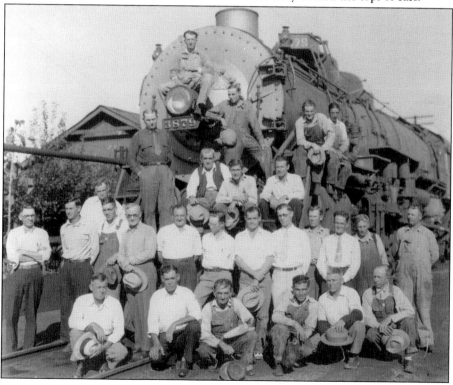

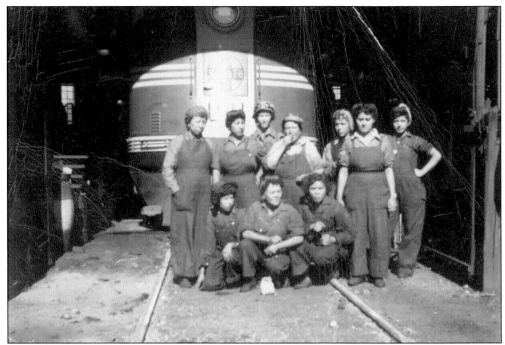

Thousands of women worked industrial jobs because of labor shortages during World War II, and Eufelia Baca (back row, center) was one of the local women hired in the Santa Fe roundhouse. Women were expected to return home after the war, but their experiences in better paying, nontraditional jobs permanently changed expectations about their roles in the workforce. (Courtesy of Sandi Baca Martinez.)

The Santa Fe employed Laguna men in exchange for the right to cross their Pueblo lands in New Mexico. Laguna families often lived in converted boxcars on Santa Fe property, as seen in this 1930s photograph of Margaret and Richard Carillo in front of their home in Winslow's Laguna Colony. To the east was the Japanese Colony, a Santa Fe housing facility for master mechanics and their families. Close relationships between the two groups ended abruptly after the 1941 bombing of Pearl Harbor, when Japanese American citizens across the West were sent to internment camps. (Courtesy of Delbert Carrillo.)

Relations were sometimes difficult between Santa Fe labor and management, as illustrated by this image of a 1951 labor dispute. From left to right, John Curnette, Burns MacLean, and Emory Stone of the Brotherhood of Locomotive Firemen and Engineers (BLFE) held up strike signs in front of Santa Fe property on the west side of town.

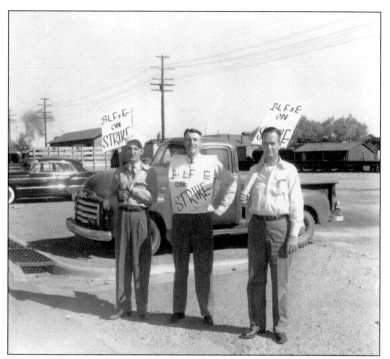

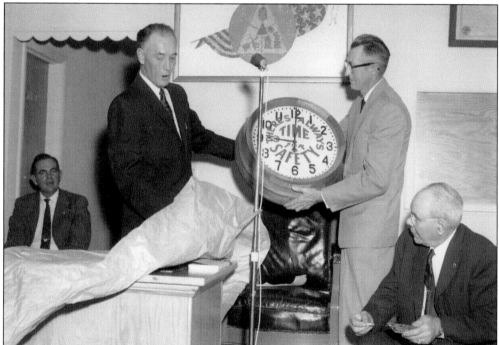

The new BLFE lodge on East First Street was dedicated on February 18, 1959. Division superintendent O.R. Hammit (left) presented a wall clock to master of ceremonies Burns MacLean and said his presence was symbolic of the improved relationship between labor and management. Also pictured are lodge president L.R. Hesser (seated, far left) and vice president Robert Eschler (seated, far right).

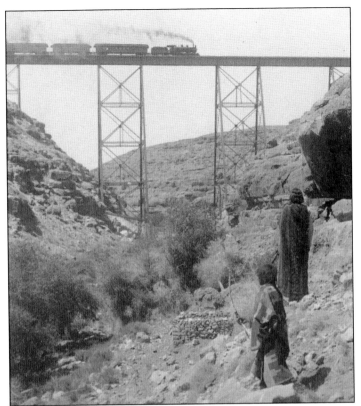

Published in 1904, the stereograph at left shows a westbound train crossing Canyon Diablo with a Navajo man and boy in the foreground. The 1882 bridge was 531 feet long and rose 223 feet above the canyon floor. Replaced in 1900, and again in 1913, the bridge was strategically important and heavily guarded during World War II. The Santa Fe's red-and-yellow diesel passenger train, the *Super Chief,* debuted in 1936 and was known for its deluxe accommodations. It is seen below, crossing the double-track incarnation of the Canyon Diablo Bridge, which was built in 1947 just north of the original and is still in use.

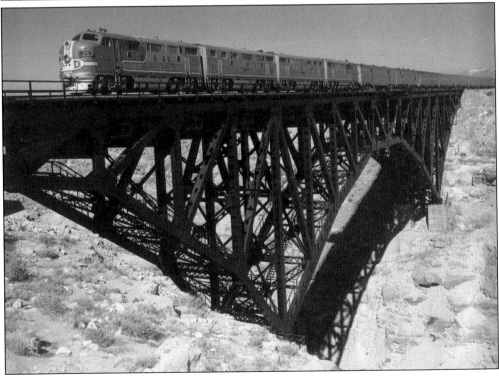

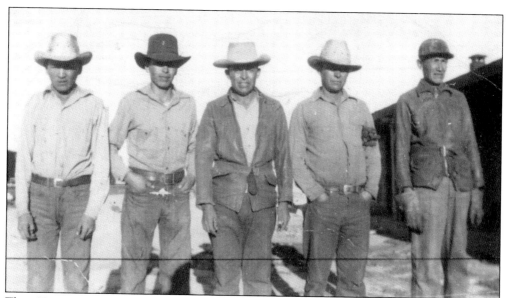

These Navajo men were employed by the Santa Fe to help build the 1947 Canyon Diablo Bridge. They are, from left to right, Rex Tsosie, unidentified, Frank Nelson, Lee Nelson, and Billy George.

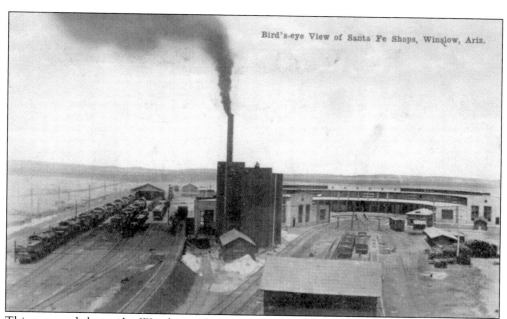

This postcard shows the Winslow rail yards in 1921 after the completion of Winslow's third roundhouse. In 1912, the engine stalls of the second roundhouse were dismantled and moved to land deeded by Joseph E. Kleindienst on the west end of town. (Courtesy of Tescue Kenna.)

The railroads developed refrigerated freight cars in 1886, opening up markets for fresh fruits and vegetables from California. Ice was manufactured in large quantities and replenished along the rail line. Winslow's first icehouse began operating in 1898 as the only plant between Albuquerque and Needles. It also supplied ice to households throughout Arizona and generated electricity for the railroad shops, depot, and Harvey House. It burned down in 1916 and was quickly replaced.

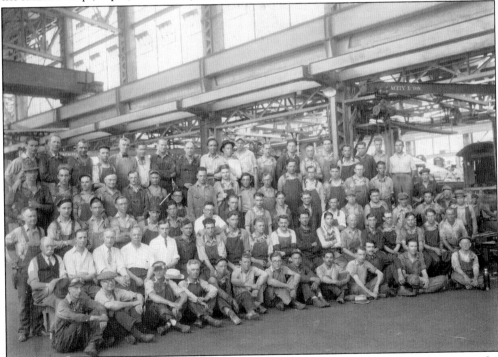

Seen here in the 1920s, Winslow's icehouse and its workforce were among the largest in the world, supplying points as far away as Kansas City, Chicago, and New York City. More employees were needed during the growing season, when the Santa Fe shipped tons of fresh produce to Eastern markets. Many workers were laid off during the winter and moved back to Mexico with their families.

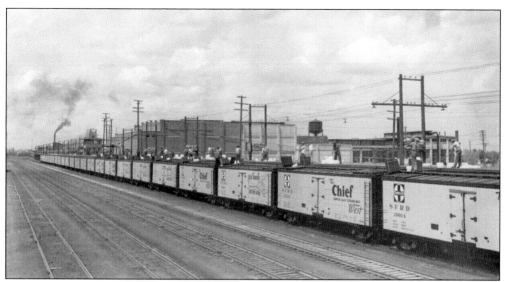

Santa Fe workers climbed on top of trains and loaded blocks of ice into boxcars, as seen in this 1950s photograph with the ice plant and roundhouse in the background. The hostler moved up to 20 cars at a time for loading at the ice plant's dock and then returned them to their trains.

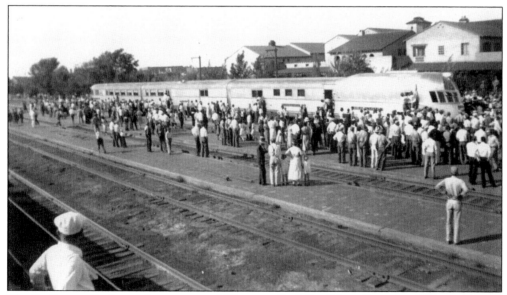

The Burlington *Zephyr* made its inaugural "Dawn-to-Dusk Run" from Denver to Chicago in 1934. Residents came to see the famous diesel locomotive at La Posada Hotel during a national tour later that year. The Santa Fe's own passenger trains were renowned for their luxury and "Harvey Car" dining rooms. During the heyday of railroad tourism, 14 of them passed through Winslow each day, including the *Grand Canyon Limited, El Capitan, California Limited, Chief,* and *Super Chief.*

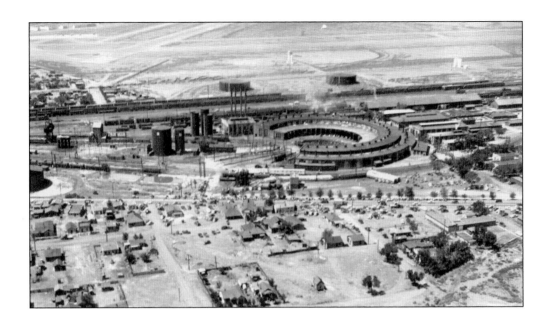

A spectacular train wreck occurred in Winslow the morning of June 29, 1948. Above, this aerial image of the scene gives a good view of the third roundhouse, the tracks to the south, and the airport runway beyond the tracks. The eastbound *Super Chief* was traveling at a high rate of speed when it jumped the curb near the roundhouse (below). The diesel locomotive, two mail cars, and a lounge car overturned and slid across the rail yard. Though no one was killed, and only eight people were injured, oil storage tanks and electrical poles were toppled, the corner of the building was torn off, and nine automobiles were crushed.

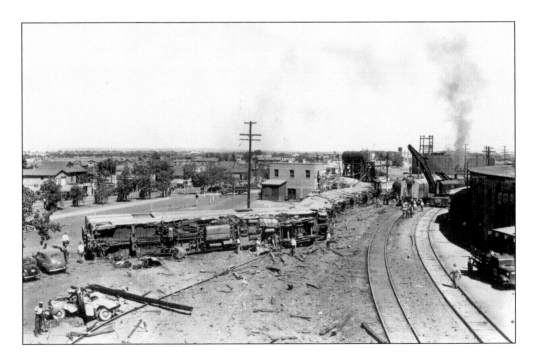

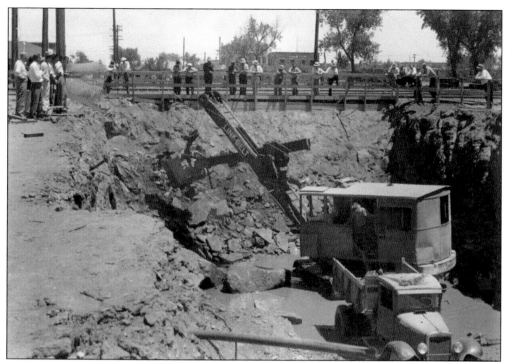

Over the years, many wagons and automobiles were involved in accidents while crossing the railroad tracks. So the Works Progress Administration, a New Deal agency active during the Great Depression, contracted with Tanner Construction Company to construct an underpass on Williamson Avenue. It took eight months to remove 14,500 cubic yards of earth, pour 3,000 cubic yards of concrete, and place 180 tons of steel in the ceiling and walls. Dignitaries from around the state celebrated with residents at the dedication on December 15, 1936.

A Santa Fe power plant to the east of the railroad depot and La Posada Hotel supplied both with electricity. After the hotel closed in 1957 and the Santa Fe moved its division offices into the building in 1963, the railroad installed new sources of power. The old smokestack was no longer needed, and a large crowd gathered to watch it fall on December 23, 1963.

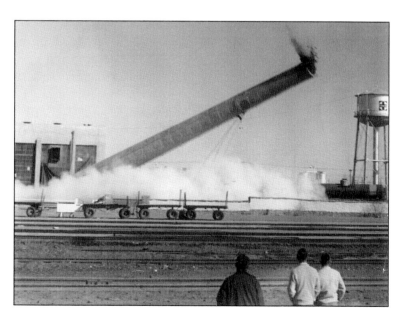

As an alternative to saloons and brothels, the A&P management established reading rooms in the 1880s where crews could read, rest, and enjoy camaraderie with their coworkers between shifts. The Santa Fe built Winslow's new reading room in 1913, seen above in the 1930s. Below, George Sutherland (right) ran the Santa Fe Reading Room in the 1950s. He is pictured with conductor Meral Hunter at the candy counter.

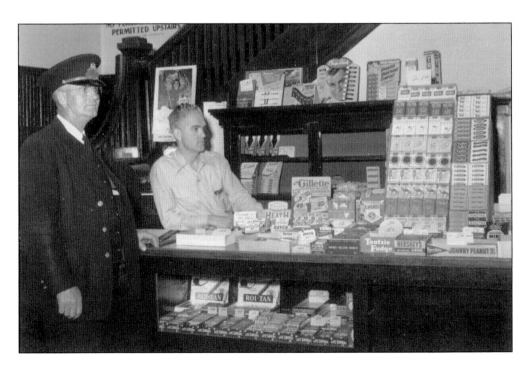

Four

FROM THE RAILROAD COMES INDUSTRY
RANCHES, TRADING POSTS, AND LUMBER

In addition to its importance as a railroad division point, Winslow's location as a livestock, trade goods, and lumber shipping point contributed to its growth and stability. The A&P and Santa Fe allowed these industries to expand, which in turn made the railroads more successful. Eastern financiers helped develop these markets, reaping profits in return, while consumers on both coasts enjoyed access to Arizona's natural and cultural resources.

When overstocking, overgrazing, and drought decimated northeastern Arizona Territory sheep and cattle populations in the 1890s, the railroad became more important than ever, linking a tenuous Arizona ranching industry to California and Midwestern markets. In addition to those discussed here, area ranchers included the Aja, Autry, Bixby, Chauncey, Clemens, Drye, Greaves, Haight, Heartz, Kaufman, Rand, Wolff, and Wyrick families. Sheepherders included the Aja, Baca, Bly, Dagg, Lujan, and Ylarrez families. Although the sheep industry has not fared as well, the area's cattle industry survives to this day, partly because of careful stewardship of both land and animals.

Soldiers opened the first trading post at Fort Defiance in 1868, exchanging household staples for Navajo wool, blankets, jewelry, and livestock, which the railroads began transporting to Eastern markets. Over a dozen Winslow families worked at nearly 30 locations throughout the region, establishing unique relationships with Navajo and Hopi artists. The families pictured here operated in or just outside of town, and additional trader names with ties to Winslow included Fisher, Hunt, Richardson, Sekakuku, Stiles, and Williams.

The logging industry was established in northeastern Arizona for two reasons: the availability of the largest stand of ponderosa pine in North America to the south, and the cost-effective shipping of finished lumber on the Santa Fe and Route 66. The industry was initially spurred by the A&P's need for railroad ties, but demand for lumber increased during World War II and the post-war housing boom. Loggers and mill workers living in Winslow worked for the Duke City Lumber Company, Nagel Lumber & Timber Company, or Ramsey Logging Company. As larger enterprises took over the industry, the days of the local, family-owned lumber mills came to an end, and the last local mill closed in 1999.

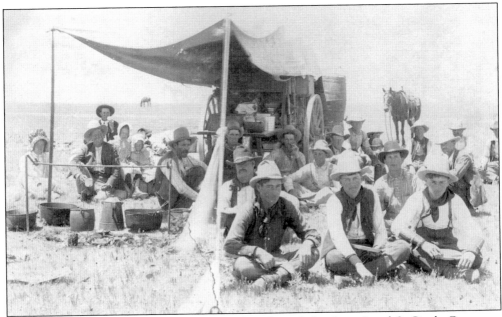

A group of eastern investors and Texas ranchers formed the Aztec Land & Cattle Company, moving 50,000 head of Texas longhorns to northeastern Arizona Territory in 1885. Known as the Hashknife Outfit for the shape of its brand, the territory's largest ranch ultimately spanned 2,000,000 acres south of Winslow, from Flagstaff to Holbrook. The Hashknife employed over 100 cowboys, many of whom came to Winslow for supplies and recreation. Pictured above around 1900 is the chuck wagon of the XIT Ranch, which owned some former Hashknife land south of Winslow.

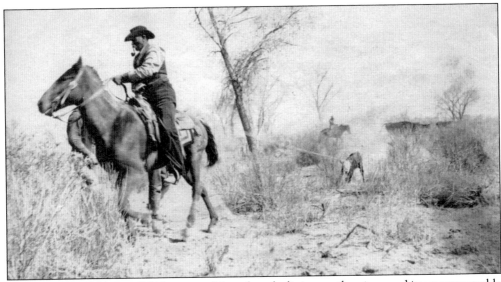

The Hashknife folded in 1900 because of droughts, declining cattle prices, and its unmanageable size. The Babbitt Brothers of Flagstaff and Charles E. Wyrick bought most of the land and the famous brand. Former Hashknife cowboy Barnett "Barney" Stiles, seen here roping a calf during his 1905 roundup, also bought some Hashknife land south of Winslow. (Courtesy of Nick Paul.)

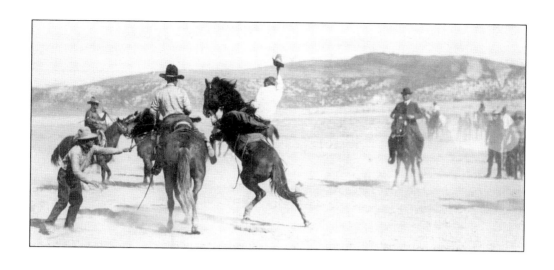

J.W. "Pop" Marley, wife Cora Agnes, their 13 children, and 2,000 head of cattle moved from Texas in 1904. Marley formed the Clear Creek Cattle Company south of Winslow, which bordered the Babbitt-Wyrick spread. Above, son Robert Silas "Heck" Marley holds his hat during their 1909 roundup east of Sunset Pass. Below, Heck's sister Gladys and his wife, Mary Brooks Marley, do some branding in the Winslow stockyards during the same roundup. Pop Marley was found guilty of rustling in 1912; he subsequently moved south to Gilbert to begin a cotton farm. (Both, courtesy of Nick Paul.)

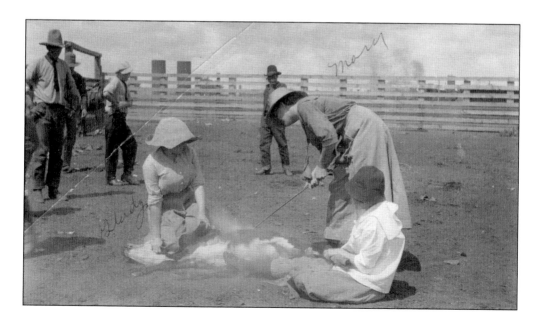

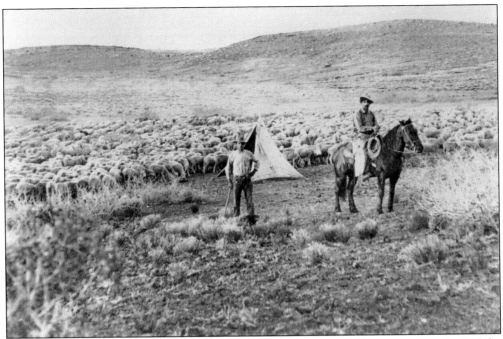

Michel O'Haco emigrated from the Basque region between Spain and France in 1899. In 1923, he formed the O'Haco Sheep Company, which became the state's largest sheep outfit. O'Haco (right) moved his sheep south for the winter; he is pictured here tending his flock north of Phoenix in 1912. His son, Michael, took over their Chevelon Butte Ranch south of Winslow and became one of Arizona's most prominent cattle ranchers. Michael's children still operate the O'Haco Cattle Company. (Courtesy of Kim O'Haco McReynolds.)

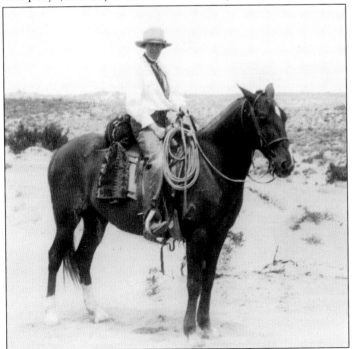

Seen here with her beloved horse, Pig, in 1929, Olive Dove Van Zoast came to Winslow in 1918 to work as a Harvey Girl (a waitress in Fred Harvey's restaurant chain). She later married livestock inspector George Creswell and changed her name to Cecil. After her husband's death, she lived a solitary life on their modest homestead south of town and eventually rustled cattle from neighboring ranches to survive. When authorities went to arrest 53-year-old Creswell in 1954, she took her own life rather than be incarcerated.

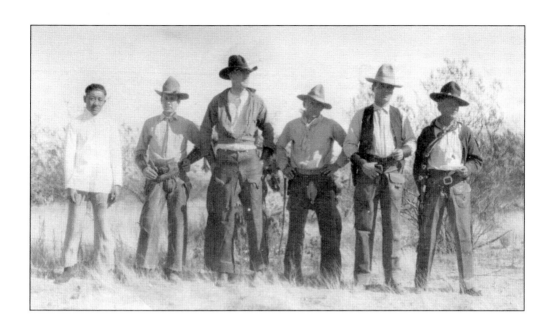

Above, C. Dewey McCauley (third from left) poses with his cook and ranch hands in the 1930s. He and wife Nina McCamant McCauley were prominent cattle ranchers in the area. Dewey also practiced law and served in the Arizona state senate. Below, Dewey's son John D. McCauley stands on his horse above Chevelon Canyon in the 1940s. The McCauleys herded their cattle through the canyon to reach the McCauley-McCamant Pine Springs Ranch southeast of Winslow, which the family still operates today. (Both, courtesy of Frances McCauley Perkins.)

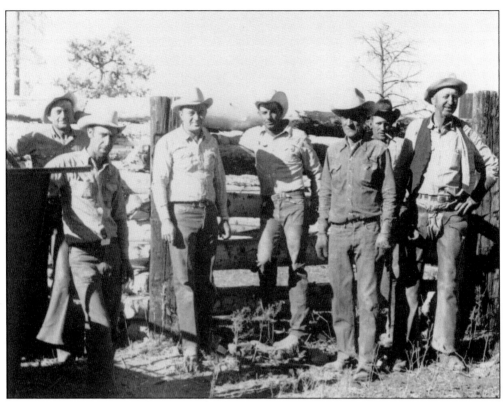

Napoleon Warren "Boss" Chilson bought the initial portion of the Bar T Bar Ranch in 1924, and the family has continued to expand and improve their lands southwest of Winslow ever since. Seen here in 1955 are, from left to right, Bus Click, Ted Sparks, Chilson's son and subsequent ranch owner Ernest Chilson, foreman Bill Ogilvie, Ora Stratton, Rufe Allen, and Jep Still. Below, cowboys herd Chilson's cattle into Winslow's stockyards before loading them onto trains in the 1960s. (Above, courtesy of Arizona State Library, Archives and Public Records, History and Archives Division, Phoenix, #01-4020; below, courtesy of Arizona Historical Society, Richard Schaus Collection MS FM MSS 6, Photographs, SCH-AMP006.)

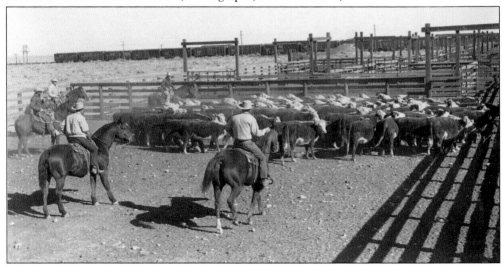

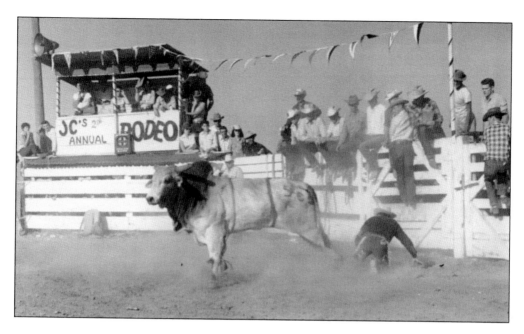

Dewey and Nina McCauley organized Winslow's first rodeo in the 1940s, and the Winslow Jaycees sponsored their second annual rodeo in 1955 (above). Below, the Jaycees added a beard-growing contest to the event in 1958, and T.W. Gill (second from right) won a year of free service at any local barbershop. Today, rodeoing has become an exhibition of skills rather than a diversion from ranch work. Members of several local families have competed nationally, including the Cordovas and O'Hacos. (Above, courtesy of Marie Sharar LaMar.)

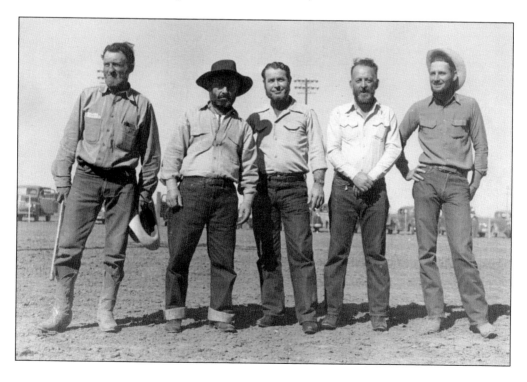

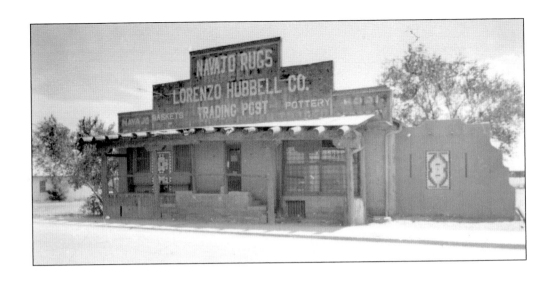

John Lorenzo Hubbell Sr. established his first trading post at Ganado, Arizona, in 1876 and headed one of Arizona's most successful and respected trader families. In 1924, Lorenzo Jr. bought Richardson's Trading Post on West Second Street (above). Brother Roman and sister-in-law Dorothy managed Winslow's Hubbell Trading Post, pictured below in the 1950s, from 1942 until 1953. The building changed owners several times before it was purchased by the City of Winslow. Listed in the National Register of Historic Places in 2002, it now serves as the Winslow Chamber of Commerce and Visitor's Center.

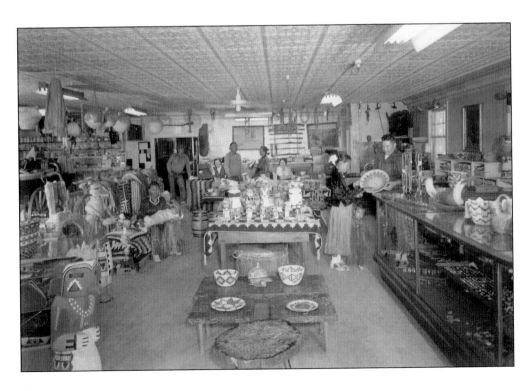

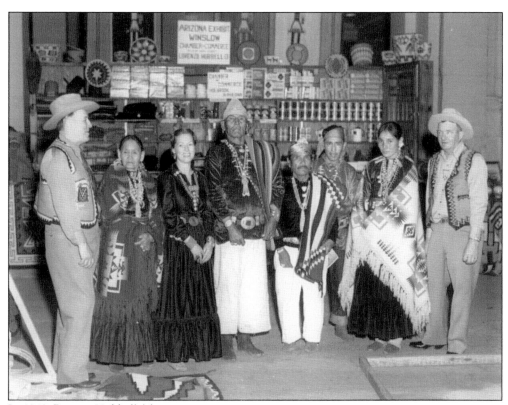

In 1948, Roman Hubbell (above, far left) and members of the Navajo Nation represented northern Arizona at the International Travel and Vacation Show in New York City. The group displayed the "World's Largest Navajo Rug," which Lorenzo Hubbell Jr. commissioned in 1932 for exhibition at the Winslow location and special events around the nation. Sam Joe of Greasewood, Arizona, near Ganado, researched the pattern and built a rock house for the oversized loom. Daughters Lilly and Erma spent two years shearing the sheep and processing the wool with their mother, Julia, who wove the rug over the next three years. In 2012, the 22-by-36-foot masterpiece was purchased by Allan Affeldt, owner of La Posada Hotel, where it will eventually be put on display.

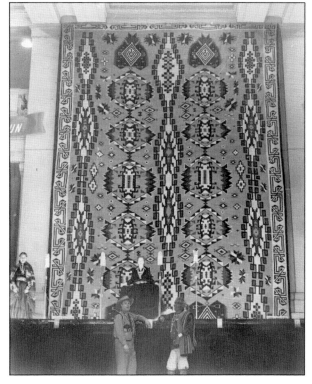

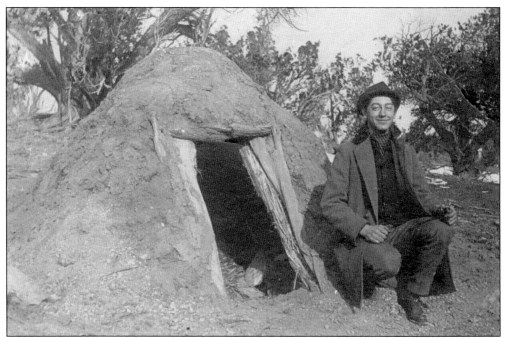

Above, posing around 1910 outside a Navajo sweat lodge, Richard M. "Otto" Bruchman was born to German parents and arrived in Arizona in 1901. He clerked at Babbitt's Mercantile for two years before purchasing the Bird Springs Trading Post, where he greeted customers in fluent English, Navajo, or Spanish. He moved his family to Winslow in 1921 and opened R.M. Bruchman & Son on West Second Street, pictured below in the 1940s. Grandchildren Dona and Phil managed the business until Phil purchased the Baker Trading Post in 1984 and started his own operation, Phil Bruchman Trading Company, on East Second Street. Dona ran the original business until 1996, and several generations of Bruchmans still reside in Winslow. (Both, courtesy of Dona Bruchman Harris.)

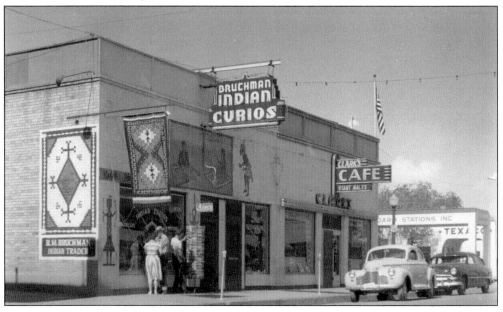

In 1944, William E. and Lucille McGee purchased Leupp Trading Post, 36 miles northwest of Winslow, from Ida Mae Borum. Their son Ralph and daughter-in-law Ellen operated it from 1954 to 1982. Pictured in the post in the 1960s are, from left to right, Hasten Bitsuie, Lamar Slowtalker's teenage son, John Billy, John Billy's small grandson, Beth Chee, Hosteen Mark Keyonnie, and Ason Keyonnie. The town of Leupp was also the site of an isolation center for interned Japanese Americans during World War II.

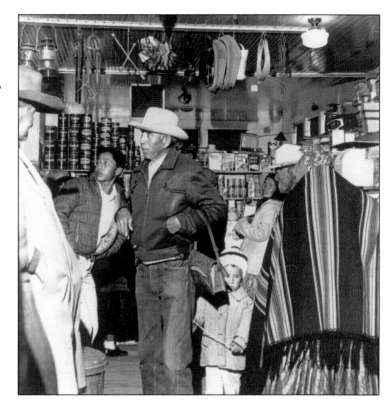

Seen here in 1914, Indian Wells Trading Post was 54 miles northeast of Winslow. By the mid-20th century, there were almost 150 posts on or near Navajo lands. Because many Native American products were produced seasonally, trading post operators played a critical role in household economies by offering a credit system. But, as more Navajos and Hopis shopped in town and sold their artwork directly to tourists, the need for the traditional trading post waned.

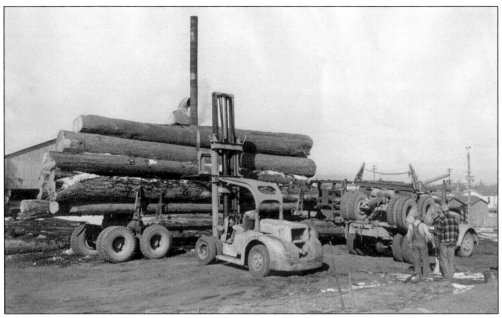

This 1940s image shows workers unloading logs at the Nagel Lumber & Timber Company, located off State Route 87 on Clear Creek Road. George H. and Mabel J. Nagel began operations in 1942, purchasing timber from the Sitgreaves National Forest south of town. Due to George's failing health, Mabel began managing the mill in 1951. She was also Winslow's first female city council member. After several fires and rebuilds, the Nagels sold to Duke City Lumber Company in 1965. (Courtesy of Georgia Nagel.)

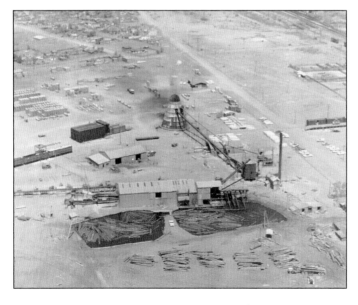

The Nagel millpond stored logs and fed them into the sawmill, and the teepee burner disposed of sawdust, bark, and other byproducts of the milling process. World War II increased the demand for lumber, as did the post-war housing boom. The Gallagher Mill opened in 1950 and was also acquired by Duke City in 1958. The Ramsey Logging Company supplied timber to Duke City's mill site just south of town. Precision Pine acquired Duke City in 1991, but closed the sawmill eight years later.

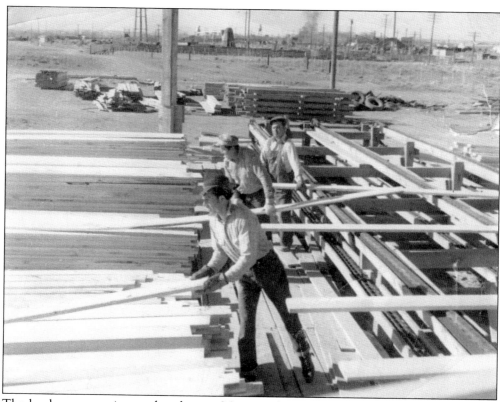

The lumber companies employed many Mexican Americans and some African Americans (generally from Louisiana via the mill town of McNary, Arizona). Above, in the 1950s, Nagel workers stacked green lumber coming from a machine they called la Cadena Verde ("the Green Chain"). Standing farthest back is Albert J. Cooper; Coopertown, or Palomas, the neighborhood south of the tracks and west of Southside, is named after his family. Below, workers wait in front of the Nagel office, perhaps for their wives or children to bring their lunches. Cooper is fourth from the right. (Both, courtesy of Dorothy Cooper Villanueva.)

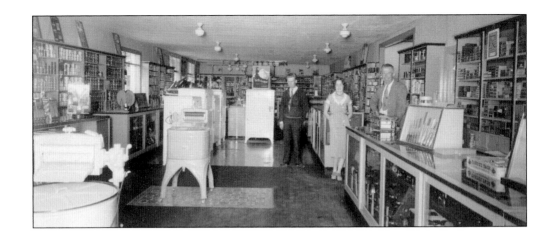

The Olds Brothers Lumber Company stood for many years at 300 Kinsley Avenue. Besides lumber, the store sold paint, building supplies, and large appliances. Pictured above around 1930 are employees Roy Sumpter (left) and Mary Kobel (center), with owner Hugh L. Boyd. Below, on June 17, 1954, the store burned in a spectacular predawn fire that sent paint cans exploding into the sky.

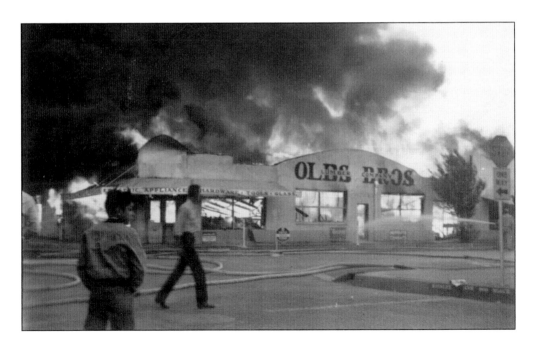

Five

TOURING THE SOUTHWEST
HARVEY HOUSES, HARVEY GIRLS,
AND LA POSADA HOTEL

Entrepreneur Fred Harvey opened a series of dining facilities in cooperation with the Santa Fe that evolved into America's first restaurant chain. Fred Harvey, as the company was known, operated from 1876 through the 1960s. Its many pioneering innovations included the refinement of dining in the West, the widespread employment of women, the development of cultural tourism, and the commercialization of Native American arts and crafts.

Fred Harvey provided exceptional meals, atmosphere, and value to railroad passengers and employees, and demanded the highest food preparation and service standards at all times. When male waiters were unable to uphold these standards to Harvey's satisfaction, he introduced the Harvey Girls in 1883. The waitressing profession had a poor reputation at that time, so Harvey Girls had to be well mannered, neat in appearance, and educated through the eighth grade. They signed six-month contracts stipulating that they would remain unmarried and lived in dormitories complete with house matrons and curfews. Despite these restrictions, over 100,000 single women from the East and Midwest took the opportunity to work respectable jobs, earn good wages, travel the country, and meet prospective husbands. Over 50,000 of them married Western men and settled in towns along the Santa Fe line. Many of Winslow's Harvey Girls eventually settled in town, where generations of their descendants still reside.

After Fred's death in 1901, son Ford Harvey expanded the company's hotel business to include tourists. Both the Santa Fe and Harvey companies began vigorously promoting travel to the Southwest, employing a comprehensive marketing strategy that drew on the region's authentic history while creating an idealized image of its landscapes and peoples. Railway travelers experienced the Southwest through Fred Harvey's grand hotels along the Santa Fe line, retail sales of Native American arts and crafts, and the Harveycar Indian Detours, the company's automobile touring service. Winslow's proximity to unique natural and cultural sites made it an ideal tourism destination, so La Posada, Fred Harvey's last grand hotel and architect Mary Colter's masterpiece, opened north of the tracks in 1930. Amfac bought Fred Harvey in 1968, but the company's influence on Winslow and the Southwest endures.

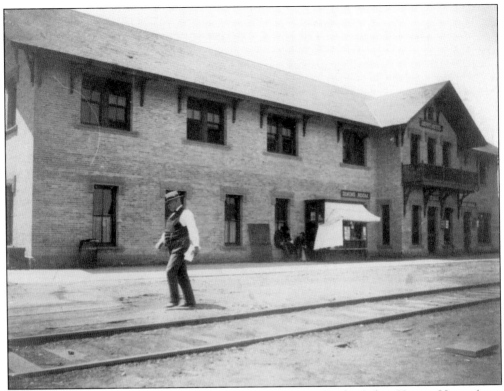

Built when the A&P was still a subsidiary of the Santa Fe, Winslow's first Harvey House (seen here behind justice of the peace James F. Mahoney) opened in 1887, south of the tracks and east of the present-day underpass. The large brick-and-sandstone structure housed a ticket office, waiting and baggage rooms, newspaper stand, lunchroom, dining room, and a second-floor hotel.

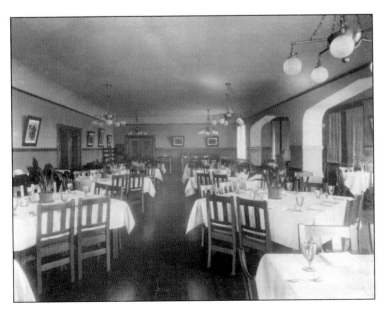

Winslow's elegant dining room provided delicious, affordable meals to railroad passengers, employees, and townspeople alike. Fred Harvey hired outstanding chefs and paid them well, and he insisted they use fresh local ingredients whenever possible. This dining room was in use until La Posada opened in 1930.

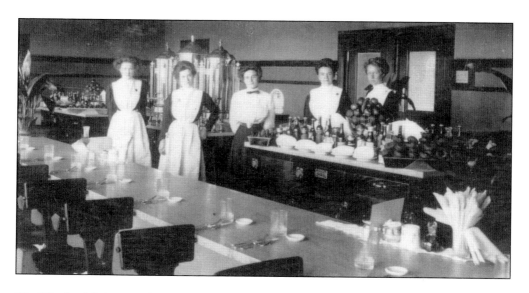

The *Winslow Mail* reported the arrival of Harvey Girls in the 1890s. Above, wearing their signature black-and-white uniforms, these Harvey Girls stood ready to serve behind Winslow's lunch counter in 1910. They typically worked 12-hour shifts six days a week, serving customers, polishing silver and coffee urns, and making fresh coffee every two hours. Below, some Winslow Harvey Girls pose outside the Harvey House with their manager, W.E. Belding, around 1920. Olive Dove Van Zoast, the rancher later known as Cecil Creswell, is third from right. The Hopi woman seated on the left is selling handmade pottery to train passengers and hotel guests, which Fred Harvey encouraged. (Above, courtesy of Arizona State Library, Archives and Public Records, History and Archives Division, Phoenix, #98-9814.)

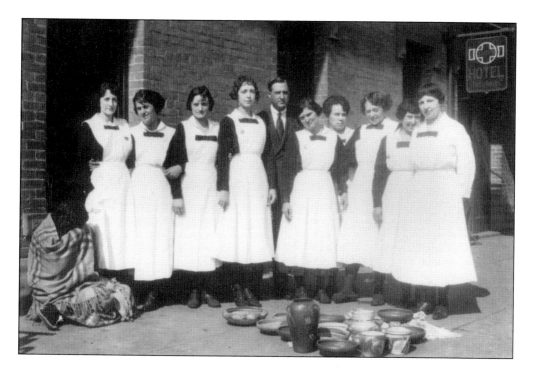

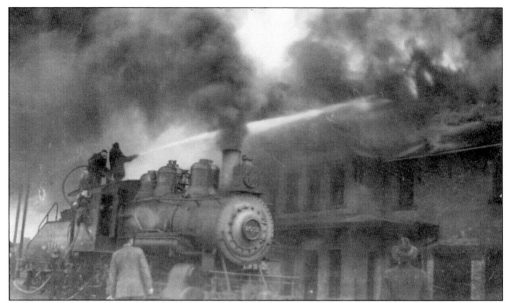

When Winslow's Harvey House caught fire in 1914, the Santa Fe brought steam engines from the roundhouse to douse the flames. Rebuilt as a much larger structure a few months later, the Harvey House is seen below with its 1927 crew, including Harvey Girls, chefs, bakers, busboys, dishwashers, and newsstand employees. The hotel also employed chambermaids, desk clerks, porters, bellhops, curio shop managers, and barbers. Manager Edwin Beahan is seated front row, center, with his wife, Mary, and daughter Dorothy. The Santa Fe used the older facility to house division offices once La Posada opened, and La Posada's Harvey Girls lived upstairs in the former hotel rooms. The building was torn down in 1964.

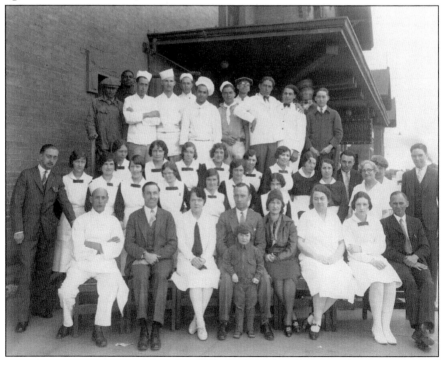

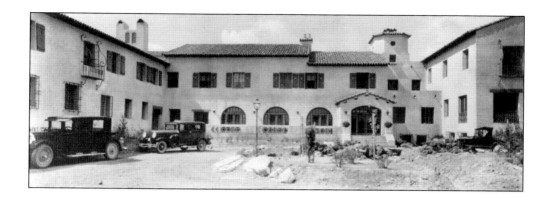

Mary Elizabeth Jane Colter worked as an architect and designer for Fred Harvey from 1902 to 1949. La Posada (Spanish for "the inn") was said to be her favorite project. The Spanish Colonial Revival hotel opened in May 1930 surrounded by 11 acres of gardens that featured a greenhouse, band shell, and riding stables. Above, this north-side view facing Route 66/Second Street shows traditional terra-cotta tiles on the rooftops, iron *rejas* (grilles) on some windows, and a cooling tower that helped ventilate the building in summer. In the 1930 photograph below, La Posada's first manager, Omar Dooms (seated in the second row, far left), poses with his staff on the south lawn. The original front entrance faced the tracks on the south side, which also included a veranda and wishing well.

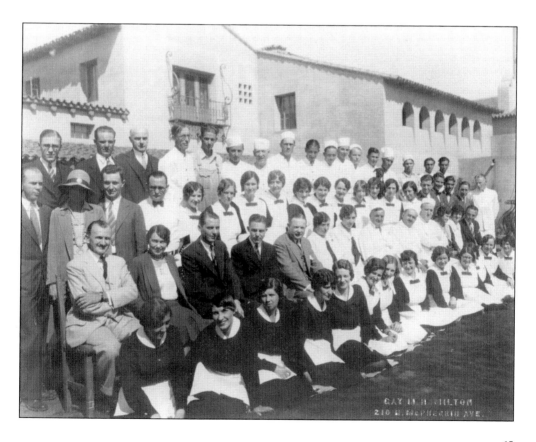

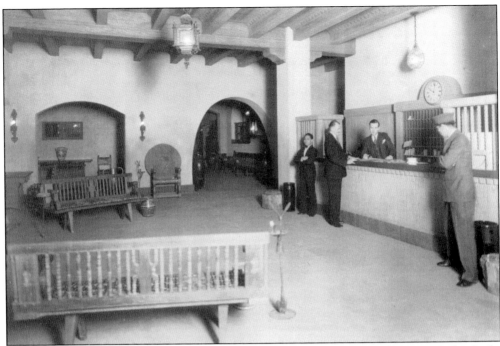

A successful female architect at a time when the profession was dominated by men, Colter had a strong personality and an exacting attention to detail and authenticity. La Posada was designed as if it had been the grand hacienda of a wealthy Spanish don, filled with flagstone floors, exposed ceiling beams, Spanish arches, wrought-iron railings, and antique and new Spanish furniture (the latter made to look old by craftsmen in the on-site wood shop). Above, Colter's whimsical jackrabbit ashtrays stood guard in the lobby, where guests checked into one of 74 guest rooms or four suites. Below, the Sunken Garden was designed to shield guests from Winslow's frequent winds. Despite opening at the start of the Great Depression at a cost of $2 million, La Posada managed to turn a profit and remained open for almost three decades.

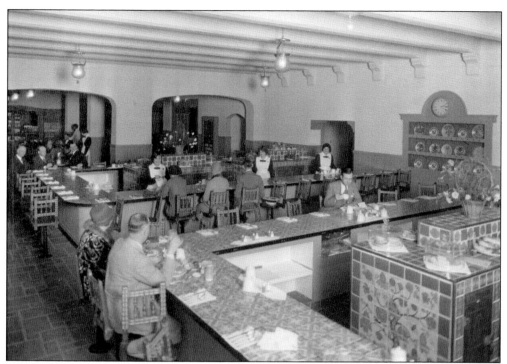

La Posada's restaurant facilities accommodated over 200 diners and included Mexican-tiled lunch counters (above), a sit-down lunchroom (below), and a formal dining room. Harvey House chefs and bakers were encouraged to develop special dishes associated with their kitchens, and blueberry muffins were one of La Posada's specialties. Grand hotel newsstands sold everything from newspapers and magazines to Fred Harvey postcards and cigars. La Posada's stand was located in the sit-down lunchroom (below), while others were often located outside, closer to the tracks. (Above, courtesy of Grand Canyon National Park #44635-21; below, courtesy of Kansas State Historical Society, #2-124.)

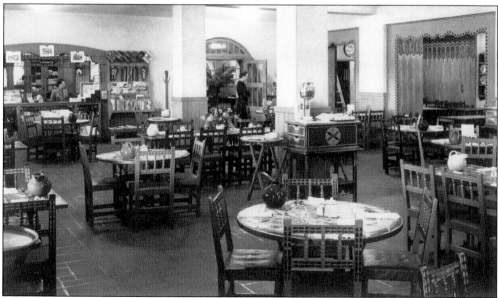

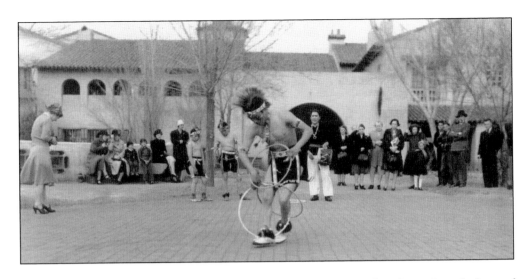

Santa Fe and Fred Harvey patrons purchased Indian-made arts and crafts in the gift shops of the grand hotels or from Native American artists selling trackside. Fred Harvey enhanced the experience by hosting artist demonstrators and performers like this hoop dancer (above) on La Posada's south patio in the 1930s. From 1926 to 1931, the company also operated the Harveycar Indian Detours, an automobile touring service that made first-class, multiday side trips from several of the grand hotels to natural and cultural sites in the Southwest (below, at La Posada). Detours were conducted by female guides called "couriers" who were trained by renowned archeologists and dressed in Navajo blouses and squash blossom necklaces. Male drivers wore cowboy shirts and 10-gallon hats. (Below, photograph by Edward A. Kemp; courtesy of the Palace of the Governors Photo Archives [NMHM/DCA], 053652.)

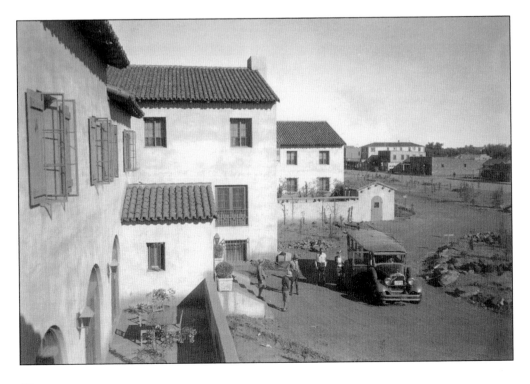

Traditional Harvey Girl uniforms were considered too severe for La Posada's southwestern setting, so colorful appliquéd aprons were introduced during World War II. As seen here on Winslow Harvey Girl Jenny Sterling in the 1940s, the handmade aprons featured cacti, donkeys, and other southwestern icons on a black background.

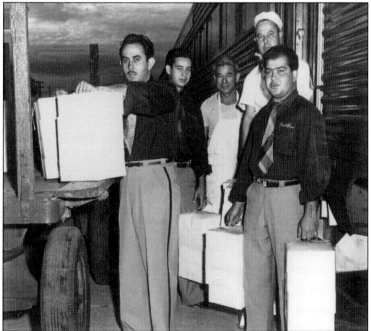

These La Posada staff members are loading box lunches onto the *Super Chief* in the 1950s. From left to right are Refugio Guzman, LeRoy Garcia, Benny Rodriguez, Avelino Perea, and son Tony Perea. Guzman was also one of La Posada's gardeners, and Rodriguez's bother Joseph was the Western artist featured in the first chapter. Santa Fe passengers also enjoyed Fred Harvey meals served in luxury dining cars.

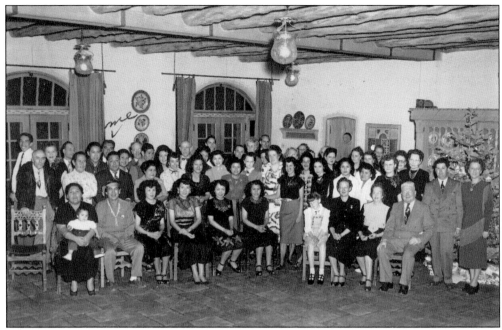

La Posada hosted special occasions of all types. Seen here is a staff Christmas party in 1948, with longtime manager Carl Weber seated at far right. Most employees enjoyed working at La Posada, and if they did not, they could request a transfer to another Harvey House.

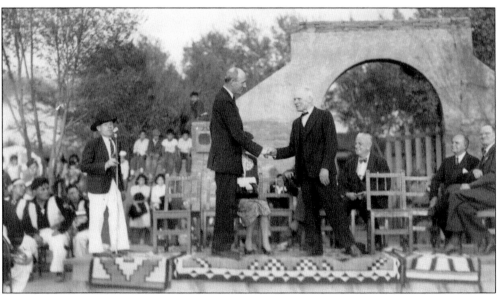

Winslow mayor James A. Greaves (center right) welcomed British ambassador to the United States Lord Halifax (center left) at the west end of La Posada's gardens in 1944. The Santa Fe All-Indian Band played at the event; band manager Charlie Erickson is standing at left. Other famous hotel guests included scientist Albert Einstein, aviator Charles Lindbergh, and movie stars Clark Gable, John Wayne, and Shirley Temple.

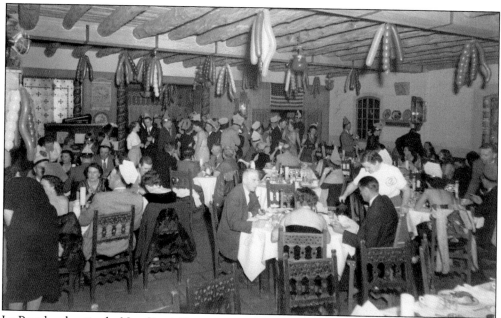

La Posada advertised a New Year's Eve party in 1953, and people came from Flagstaff, Holbrook, and Show Low to celebrate with dancing in the ballroom and dinner in the formal dining room. San Pasqual, patron saint of feasts, graced a large tile mosaic in the dining room, where community groups frequently held banquets. A printing press in La Posada's basement printed daily menus, as well as customized versions for special occasions.

For 30 years, La Posada served northern Arizona as a location for special events, such as the Severson wedding in the 1950s. However, railroad travel began its decline even before the Great Depression. Faster, more efficient trains rendered stops less necessary, and the explosion of automobiles and highways encouraged tourists to design their own itineraries. Fred Harvey began closing trackside restaurants and hotels in the 1930s.

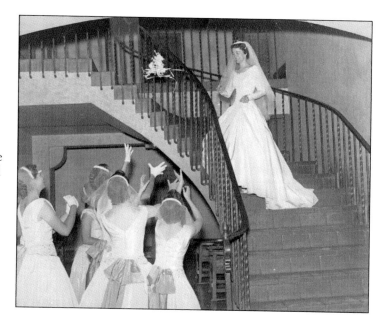

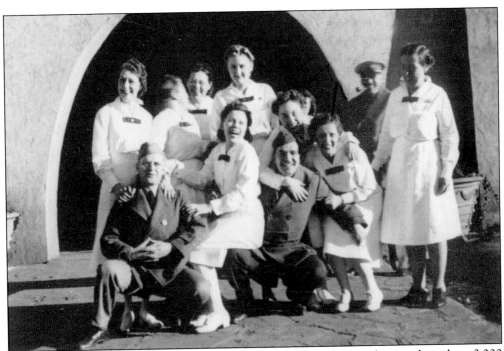

World War II temporarily reversed the downward spiral, and La Posada served meals to 3,000 soldiers a day riding into town on "troop trains" (above). Though auto-tourism boomed after the war along Route 66, travelers sought more modest accommodations, and many Harvey restaurants and hotels were demolished. La Posada closed in 1957, but escaped the wrecking ball when the Santa Fe converted it into its Albuquerque Division offices (below). Meanwhile, a group of local volunteers called the Gardening Angels tended the grounds, Old Trails Museum director Janice Griffith and the Winslow City Council got the building listed in the National Register of Historic Places in 1992, and the La Posada Foundation organized to secure grant funds to save the building. In 1997, Allan Affeldt and his wife, artist Tina Mion, purchased La Posada and reopened it with their partner, artist Daniel Lutzick, as a premier hotel and gardens. (Above, courtesy of Arizona State Library, Archives and Public Records, History and Archives Division, Phoenix, #01-4731.)

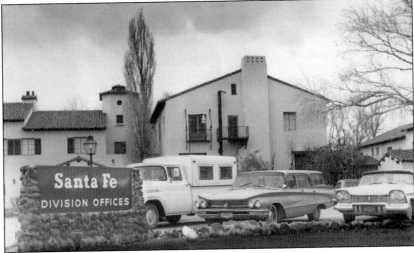

Six

TRANSPORTATION CORRIDOR
ROUTE 66 AND WINSLOW'S AIRPORT

The Santa Fe line has not been the only transportation corridor to have a dramatic impact on Winslow. In 1926, the section of the transcontinental National Old Trails Highway running from Los Angeles to New Mexico was designated part of US Route 66, which continued on to Chicago. Designed to link small towns to bigger cities and enhance their economies in the process, Route 66 passed through Winslow's downtown on Second Street. The iconic highway has influenced the city's growth, heyday, decline, and renewal ever since.

Several thousand cars drove through downtown Winslow each day during the 1950s boom years. Route 66's success, however, ultimately proved to be its downfall. Congestion and safety issues, along with national defense concerns during the Cold War, prompted the passage of the Federal Aid Highway Act of 1956. Interstate 40 bypassed Winslow in October 1979, sounding the death knell for its vibrant downtown. But there has been a revival of Route 66 appreciation and activity in recent years. Constantly flowing with tourists, Winslow's section of Historic Route 66 is the foundation of current downtown revitalization.

Winslow is also known for its airport, which played a pioneering role in early air travel. As a technical advisor for Transcontinental Air Transport (TAT), aviator Charles A. Lindbergh was charged with finding a route for its new coast-to-coast passenger service. He selected Winslow as a stopover point between Albuquerque and Los Angeles because of its terrain, weather patterns, and access to the Santa Fe line. Early aircraft needed to stop for fuel often, so Winslow's new airport became one of 12 critical refueling points on the transcontinental route. Passengers taking the 48-hour, New York–to–Los Angeles trip would fly during the day and ride the train at night.

When the United States entered World War II in 1941, the military converted the airport into a refueling and repair stop for military aircraft. Commercial passenger flights resumed after the war, but were discontinued in the 1980s because of high costs and lack of passengers. The city-owned facility was renamed the Winslow-Lindbergh Regional Airport in 1998, and the terminal has been restored to its original style. The airport is still used for private aviation, medical transport helicopters, and as a fire suppression base for the US Forest Service.

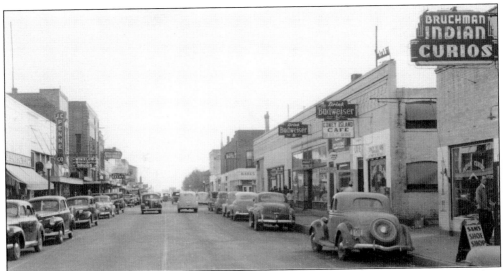

By the 1920s, travel was no longer just for the wealthy. The proliferation of automobiles traveling Route 66, seen here looking east from Warren Avenue in the 1940s, brought more tourists through Winslow than did the Santa Fe or Harvey House. Travelers turned away from the tracks and stayed at the new motor courts and campgrounds, and they were joined by townspeople in patronizing the service stations, diners, curio shops, and roadside attractions that catered to auto-tourism.

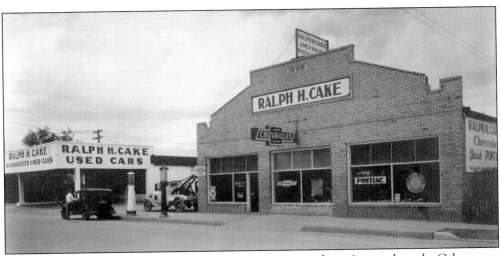

Motorists driving across the rough stretches of Route 66 in northern Arizona kept the Cake garage busy. In 1929, Ralph H. Cake moved to Winslow from California to take over the Chevrolet dealership on Route 66. He moved the business to this Third Street location in 1933 when he added Buick and Pontiac franchises.

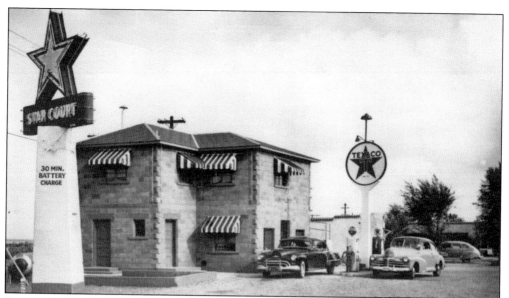

Romanticized in songs, movies, and on television, "the Main Street of America" spurred more tourism and travel-related business than ever once gasoline and rubber rationing ended after World War II. Seen here in the 1940s, the Texaco Star Court prospered accordingly on West Second Street at Indiana Avenue.

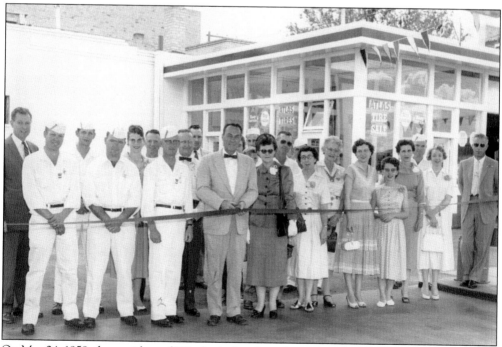

On May 24, 1958, the president of Winslow's chamber of commerce, Ted R. Jenkins, cut the ribbon for the new Standard station on West Second Street. Beside him to the left is station manager John E. Larson. Other attendees included employees, Standard Oil officials, and interested citizens. The building cost $22,000 and boasted the most modern equipment available.

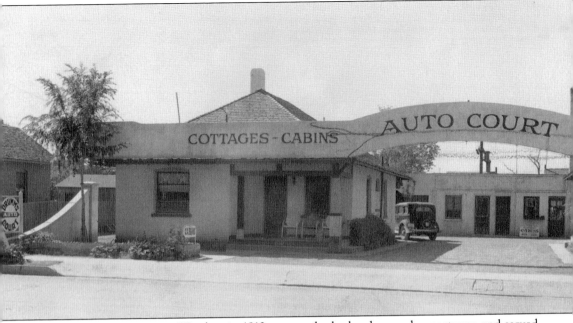

John B. Drumm came to Winslow in 1910, operated a barbershop and a mortuary, and served as justice of the peace. He opened the 20-unit Drumm Auto Court in 1937 with his wife, Frona Parr Drumm, who was also Winslow's first female insurance agent. By 1949, Winslow's 11 auto

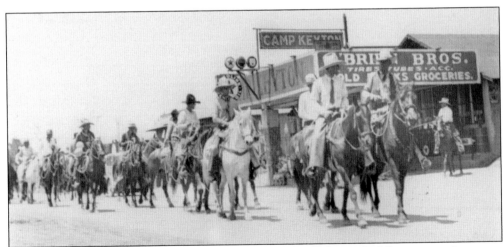

Cowboys ride past Camp Keyton during this 1930s Fourth of July parade. Like most tourist camps, Camp Keyton offered cabins, gasoline, tires, and groceries to weary travelers, including Dust Bowl refugees headed for California during the Great Depression. By 1938, all of Route 66 had been paved through a New Deal public works project that employed thousands. Both the Depression and World War II brought people through Winslow, and many who decided to stay lived at tourist camps while awaiting housing.

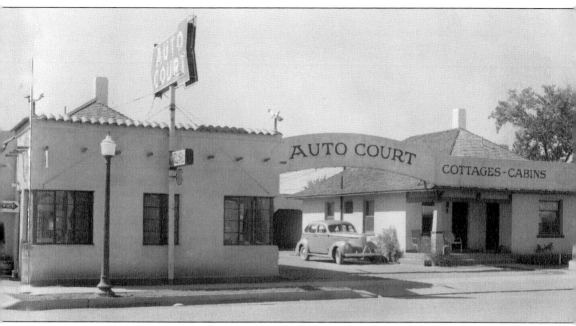

courts and two hotels could accommodate almost 1,000 travelers. Other tourist camps on Route 66 included Camp Keyton, West End Camp, and Bazell Camp Ground, which became Bazell Modern Court after a 1950 remodel.

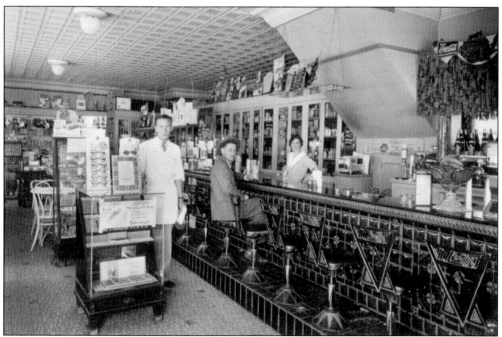

In the 1930s, drugstores occupied three of the four corners at the intersection of Second Street and Kinsley Avenue. Pictured in 1930, Herman Sughrue (far left) operated the Winslow Drug & Soda Fountain on the northwest corner. His inventory included jewelry, eyeglasses, greeting cards, cigars, chocolates, and medicines of all kinds.

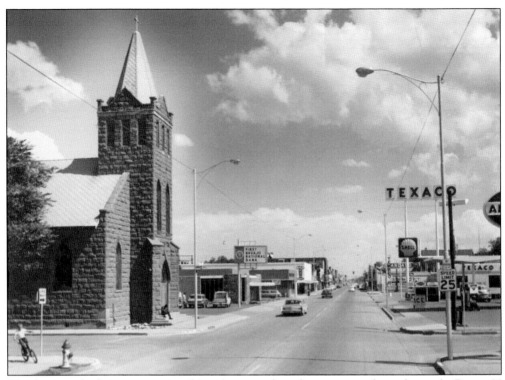

Winslow was the largest city in northern Arizona when the city council voted to make Route 66 one-way through downtown in 1953. Highway traffic had been bottlenecked on Second Street for years, and downtown Winslow had received the lowest efficiency rating of any stretch of Route 66. Third Street became westbound and Second Street (pictured here, with St. Joseph's Catholic Church on the left) became eastbound.

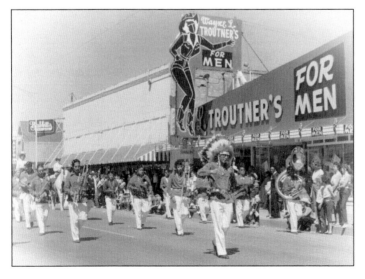

The Santa Fe All-Indian Band paraded by Babbitt Brother's Trading Company and Wayne L. Troutner's Store for Men in 1959. Troutner's curvy cowgirl logo graced hundreds of billboards along Route 66. They lured curious tourists to the iconic men's clothing store, which sold its own cologne called Essence of 66. The Babbitt building now houses Snowdrift Art Space; the Troutner building burned down in 1994.

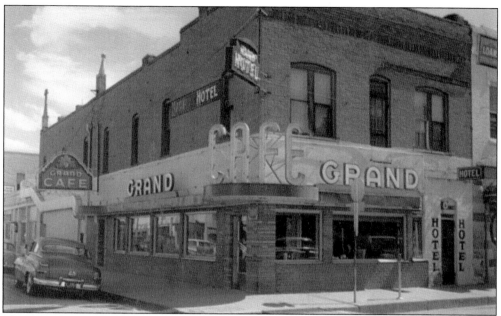

The Grand Café was located on East Second Street at Kinsley Avenue. The popular eatery was known among tourists and local teenagers alike as the place for juicy hamburgers, French fries smothered with gravy, and milkshakes. The building was demolished in the late 1960s and replaced with the Two Stars Café, which specialized in Chinese food.

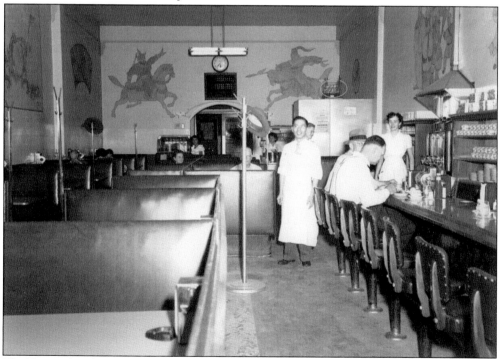

The National Café opened on East Second Street in 1937 and served both Chinese and American cuisine. Standing is Harry Lee, the longtime proprietor of the diner. Route 66 motorists could stop by 24 hours a day for a hot cup of coffee and a bite to eat.

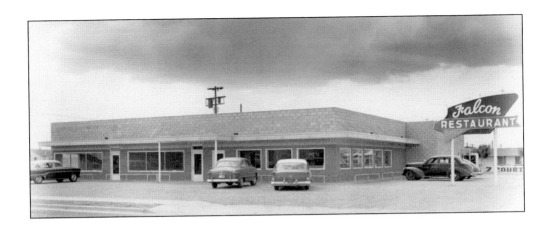

Jim, George, and Pete Kretsedemas came to Winslow from Greece to join an uncle in running the Falcon Restaurant, which opened on East Third Street in 1955 (above). The brothers operated the restaurant for the next 43 years, making the Falcon a repeat stop for thousands of Route 66 travelers. They also served generations of locals, many of whom held meetings and special receptions in the banquet room. Joseph Estudillo currently owns and operates the Falcon.

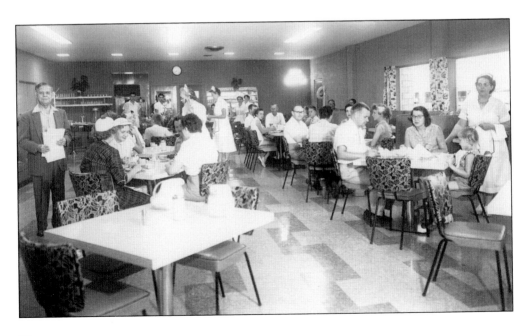

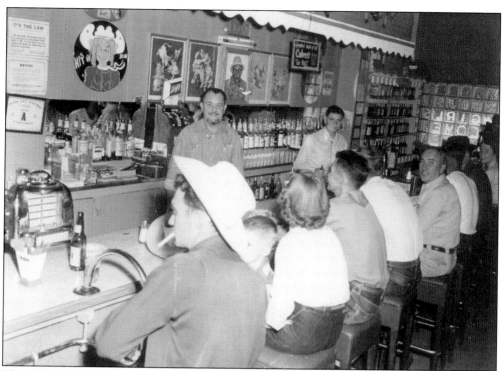

The Skylark on West Second Street was known as a rowdy cowboy bar during the 1950s heyday of Route 66. Lindsay Neal is behind the bar on the right, and young Randy Neal (second from left) sits at the bar with their mother, Anne. (Courtesy of Randy Neal.)

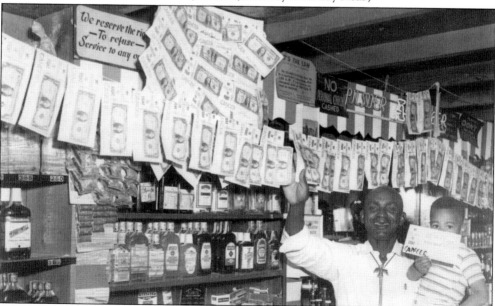

Prairie Moon proprietor Minor "Jasper" Renfro and grandson Alfonzo S. Renfro display donations collected during a fundraiser for cancer research in the mid-1960s. The West Second Street bar hosted many musicians over the years, from regional talents like bluesman Tommy Dukes to a 1966 performance by Michael Jackson, who had relatives in town. (Courtesy of Suzie Welch Renfro.)

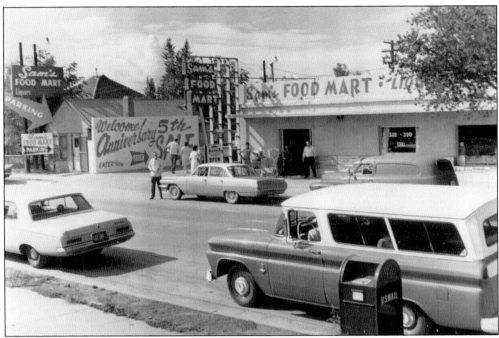

Dan "Sam" Woo opened a grocery store on East First Street on the first floor of the Statler Hotel. Woo, his daughter, Linda, and her family lived on the second floor from 1948 to 1953. Above, Woo, standing to the right of the front door, purchased the East Third Street store in 1960 (pictured here during its fifth anniversary sale in 1965). Below, Borden's Milk sponsored the celebration with music, balloons, and drawings for free groceries. Woo's family operated the store until it closed in the 1990s. (Both, courtesy of Spencer SooHoo.)

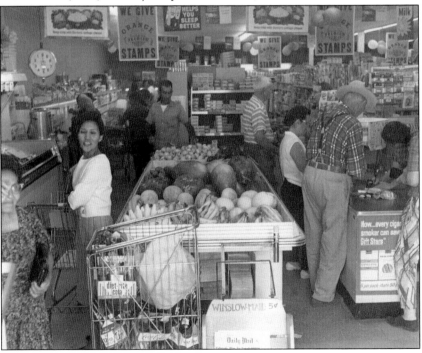

Shue Bow Woo operated the W. Bow Meat Market & Grocery on Kinsley Avenue for 43 years. His free delivery service was critical to Southside and Coopertown residents who lived too far to walk with groceries. Bow arrived from China in 1932, and he and his wife, Susie, raised five children in an apartment above the store.

The corner of Second Street and Williamson Avenue is seen here after a rainstorm in the 1950s. Winslow's Route 66 nightlife was bustling with people patronizing the Rialto Theatre; the Skylark and Green Lantern Bars; the Grand, National, and White Cafés; and numerous drugstore soda fountains. Travelers could check into the Winslow Hotel, seen here, or a number of other lodging options without having to leave the route.

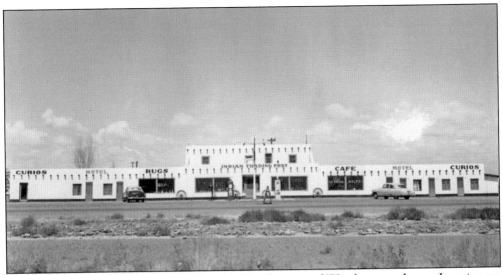

The Hopi House Indian Trading Post stood 10 miles west of Winslow near Leupp Junction on Route 66. It had gas pumps and housed a curio shop, café, and a few motel rooms. Like so many others, the business did not survive the bypass of Route 66 by Interstate 40 in 1979.

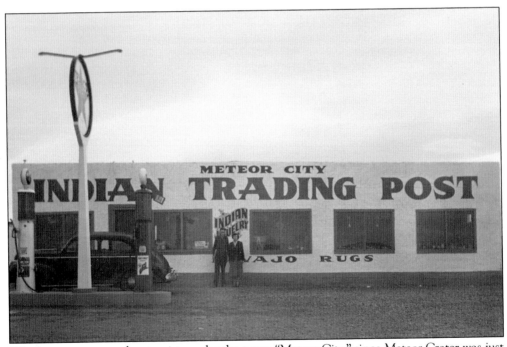

Winslow was promoted to tourists under the name "Meteor City," since Meteor Crater was just 22 miles west of town on Route 66. Meteor City Indian Trading Post opened as a service station in 1938 halfway between the two. In 1941, Jack Newsome added a curio shop, selling Indian jewelry, moccasins, petrified wood, and road maps with his wife, Gloria. The business burned in the 1960s, was rebuilt as a geodesic dome, and closed in 2012.

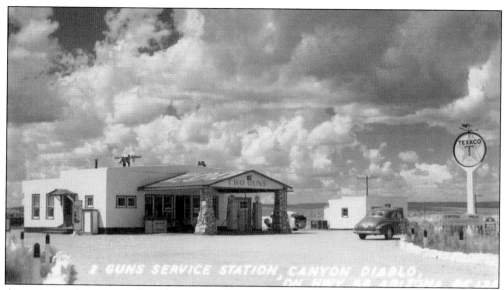

A service station operated on this site near Canyon Diablo as early as 1924 and was named Two Guns the following year. Phillip Hesch constructed this store, station, and residence in 1934, along with a roadside zoo in the back. Benjamin Dreher built a modern motel and station at Two Guns in 1963, but it burned in 1971, leaving only ruins on view for today's Route 66 enthusiasts.

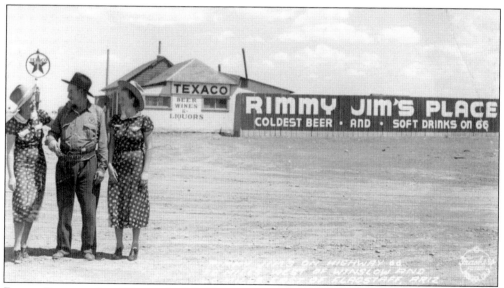

Former Texas cowboy "Rimmy Jim" Giddings ran a service station and curio shop on the corner of Route 66 and Meteor Crater Road, at a location he leased from Winslow residents Harry and Hope Locke. Giddings attracted as many customers with his legendary wit and hospitality as with his merchandise. He died in 1943, and Ruth and Sid Griffin ran the business until it was bypassed by Interstate 40.

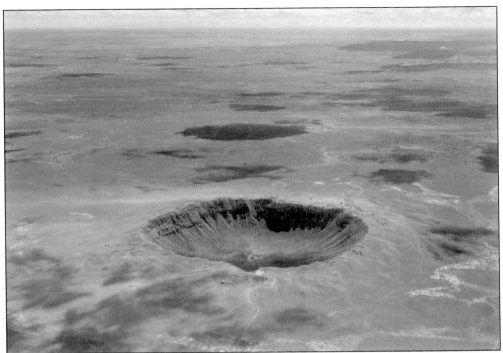

Mining engineer Daniel Moureau Barringer secured a land patent for Meteor Crater (above) in 1903 and spent the rest of his life trying to prove it was a meteorite impact crater rather than a volcano. He died in 1929, and scientist Eugene Shoemaker finally confirmed his theory in 1963. Cartoonist Harry Locke was interested in Barringer's work and opened Meteor Crater Observatory in the late 1930s. Dr. Harvey and Addie Nininger opened the American Meteorite Museum in the observatory building (below) in 1946. It housed over 5,000 meteorites and became a renowned center for research, but it closed in 1953 after Route 66 was rerouted. Over 500 feet deep and 4,000 feet across, Meteor Crater National Natural Landmark is now a privately owned tourist attraction as well as a place of scientific study.

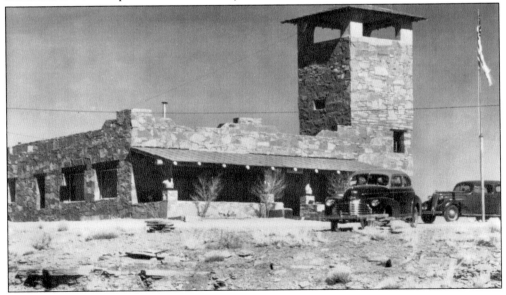

In addition to choosing Winslow as a stopover point for TAT's new coast-to-coast passenger service, Charles Lindbergh also planned its new airport. He chose the flat, open landscape south of town for a terminal, hangar, parking apron, and three long asphalt runways. The terminal and hangar are seen here around 1930.

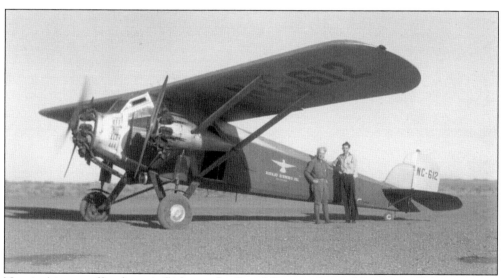

Navajo Airways offered scenic flights to the Grand Canyon, Painted Desert, and Meteor Crater. Dr. Clyde Fisher (left), curator of astronomy at the American Museum of Natural History, took the image on the opposite page during an aerial study of the crater in 1933. Pilot Jack Irish (right) flew the Kreutzer trimotor, which was soon purchased by the City of Winslow. The first city in Arizona to have a municipal airplane, Winslow used it for ambulance service and to fly city officials and council members around the state.

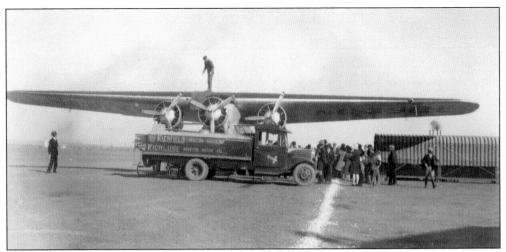

Above, TAT flew a fleet of Ford Tri-Motor planes that held 10 passengers and contained small kitchens for in-flight meals (provided, for a brief period, by Fred Harvey). In 1930, TAT merged with Western Air Express to form Transcontinental & Western Air (TWA). Left, Joseph Kasulaitis (with friend Vida Norman) worked at the airport from 1929 to 1948, during which time he met many famous aviators and movie actors, including Charles Lindbergh, Amelia Earhart, Howard Hughes, Will Rogers, and Jimmy Stewart.

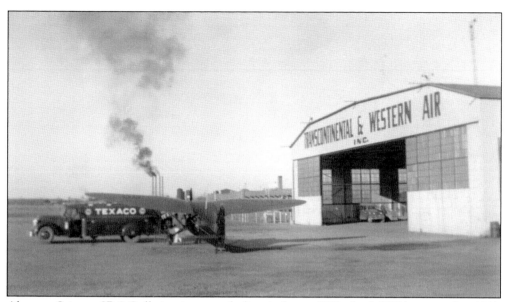

Above, a Stinson SR-9 Gullwing is seen refueling in front of Winslow's TWA terminal in 1941, the same year the airline deeded the airport land to the City of Winslow. The parties agreed to allow the government to further develop and improve the renamed Winslow Municipal Airport. When the United States entered World War II later that year, the military transformed the airport into a refueling and repair stop for military aircraft. Below, the War Department redesigned the runways (right) and had them lighted and properly drained. Starting in 1942, over 350 military flights passed through Winslow daily, including bombers, fighters, and cargo planes.

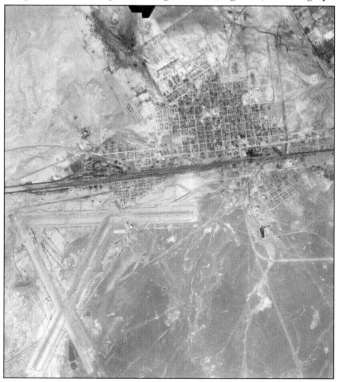

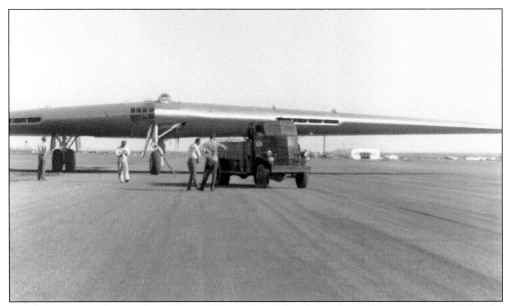

In February 1949, the Northrop YB-49 "Flying Wing" lost four of its eight engines over Colorado. Winslow was chosen for the emergency landing because of its good approach and long runways. The jet remained at the airport under close military guard for over a week awaiting replacement parts. This plane was one of only two of its kind, and its design was the precursor to the stealth bomber.

TWA resumed commercial flights after the war, became Trans World Airways in 1950, and was joined by Frontier Airlines as a Winslow carrier that same year. Acting postmaster Mary G. Ferguson is pictured handing a bag of airmail to Mayor Floyd C. Whipple in the mid-1950s. Behind them are, from left to right, Carlton K. Foster, Joe Wetzel, an unidentified Frontier Airlines attendant, and Jim Lovitt.

Seven

CIVIC LIFE
GOVERNMENT, SERVICES, AND EDUCATION

Winslow was often affected by what was happening beyond city limits. Residents volunteered to serve in every conflict the United States entered, and those on the home front supported the war efforts in whatever ways they could. As in other American towns, the federal or state government sometimes prompted Winslow to adhere to new laws, such as those requiring desegregation of schools and public facilities. Meanwhile, Winslow City Council made local policy and infrastructure improvements as its budget and vision allowed.

Since Winslow was a Santa Fe division point, it was one of the few towns in the area to have resident caregivers in the late 1800s and early 1900s. Early practitioners, such as Drs. Oscar Brown and Paul D. Sprankle, usually started out as Santa Fe physicians before opening private practices. In the early days, Winslow doctors often went to extraordinary lengths to treat patients who lacked money or lived outside of town.

Cities and towns all over the Southwest experienced a population boom after World War II, and Winslow was no exception. In addition to the schools pictured in this chapter, the Winslow Unified School District opened three elementary schools (Jefferson Elementary in 1949, Bonnie Brennan Elementary in 1961, and the new Washington Elementary in 1979), and established Winslow Junior High School in 1955. Project Head Start began in 1965, and the Northern Arizona Academy charter school opened in the former Armory Building on Airport Road in 1996. A Native American dormitory opened in Winslow in 1956. Originally named Emmons Hall, it was renovated and renamed Winslow Residential Hall in 1990 and houses Navajo, Hopi, and Apache students while they attend Winslow High School.

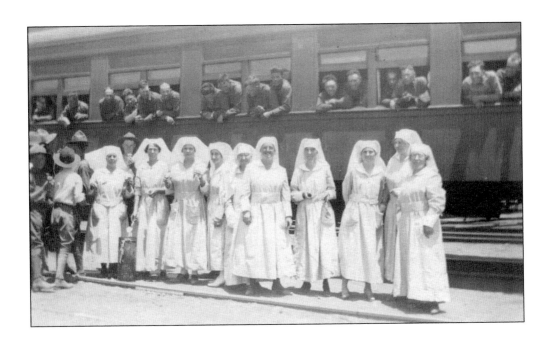

Above, Red Cross workers met the troop trains that regularly passed through town during World War I, offering encouragement and homemade cookies. One soldier wrote the *Winslow Mail* to express his thanks for the hospitality, saying, "It was the only good eats and good time shown us on the entire trip . . . we will remember Winslow in the trenches." Below, in April 1918, the Ladies Liberty Loan Committee organized a Liberty Loan Parade that included floats, flag bearers, 50 decorated automobiles, 200 Santa Fe employees, the Chinese and Japanese American Societies, and the fire truck carrying a goat dressed like the German kaiser. The parade ended on First Street, where patriotic speeches urged citizens to buy bonds and help finance the war effort.

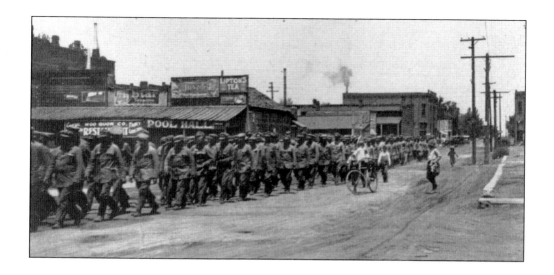

In July 1919, four trains carrying nearly 2,000 homeward-bound Czechoslovakian soldiers stopped for water in Winslow. All had been wounded while fighting with the Allies in Russia. As they were exercising by marching through the streets and singing battle hymns, local Harvey Girl Anna Garcia spotted a childhood friend from her hometown. When the other soldiers realized she was from their country, they gathered around and sang folk songs to her.

During the Cold War, the US military established radar sites across the country to detect foreign air attacks. The 904th Aircraft Control & Warning Squadron began operations on Tucker Mesa, just west of Winslow, in 1955. The almost 300 military personnel stationed there often participated in local events, including this visit from President Sukarno of Indonesia in 1956. The Air Force closed the base in 1963 due to a restructuring of the air defense system.

Maj. Jay R. Vargas graduated from Winslow High School in 1956. He received the Congressional Medal of Honor in 1970 for acts of bravery in combat while serving in Vietnam in 1968. Though Vargas never resided in Winslow after he joined the Marines, he credits the town with helping to mold his character. He generously donated a copy of his medal and one of his uniforms to the Old Trails Museum.

The Winslow Police Department posed for this photograph in 1956. Pictured are, from left to right, (first row) Bill Gonzales, Roy Madrid, Bill Acree, Elmer Randolph, Officer ? Smith, and Smith's dog; (second row) Fred Swagerty, Tex Whittington, Mayor Floyd Whipple, Ted McBride, Inis Myers (the matron in charge of detained women and children), Chief Vernon Mitchell, Councilman C.L. Cesar, Lorenzo Baca, and Harley Nelson.

In 1930, the Winslow Fire Department posed with their mascot, Boots, in front of a 1926 LaFrance fire truck that is currently being restored. The former city hall on East Second Street also served as the fire station, jail, city offices, and council chambers.

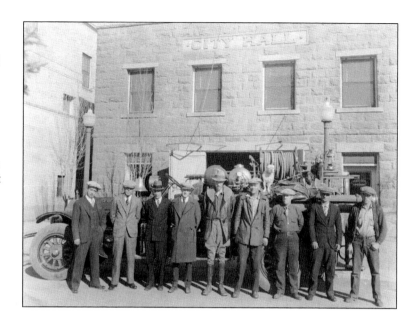

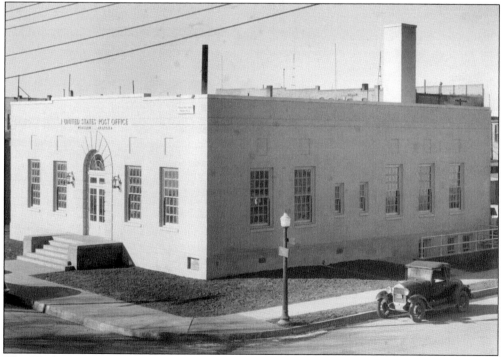

The Works Progress Administration (WPA), one of Pres. Franklin D. Roosevelt's New Deal programs in response to the Great Depression, cooperated with communities nationwide to construct public works and buildings. Winslow's new US post office was dedicated on January 11, 1936, at the corner of Williamson Avenue and Third Street. It is still in use today, as are other WPA projects that include the railroad underpass, Head Start building, municipal pool, baseball park, and city hall.

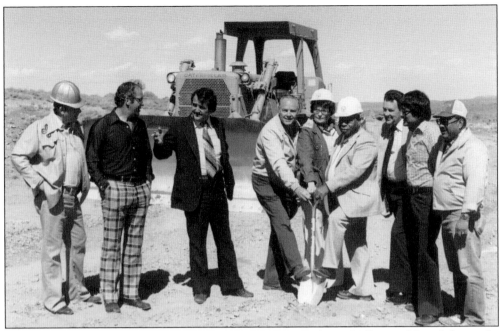

The city broke ground for the new Clear Creek Dam on April 3, 1979. Pictured from left to right are Mike Hendrix, Jack Lane, Arturo de la Cerda, Lee Dover, Pat Engelhardt, Ralph Simmons, Sherwood Rodgers, Audy Wilson, and Bob Chacon. Dover worked on the bill that created the State Lake Improvement Fund, enabling Winslow to build the dam and enlarge the recreation area later named McHood Park.

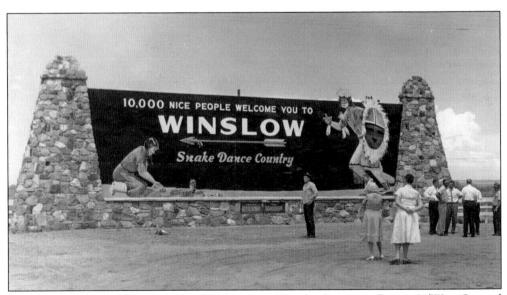

Chief Joe Sekakuku christened the "Welcome to Winslow" sign on Route 66/West Second Street during its 1951 dedication ceremony. The sign, which was constructed using native stone and petrified wood, was paid for by the city, chamber of commerce, local businesses, and several individuals. Moore and Moore Pawn now owns and advertises on the sign.

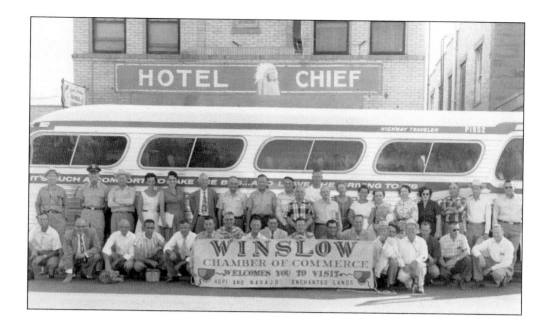

The Winslow Chamber of Commerce promoted the city to businesses and tourists in a variety of ways. Above, a goodwill tour to visit the Hopi Reservation departed on June 19, 1958. Below, Mayor Whipple presented a 1954 Ford to resident and contest winner Gilbert Salazar, a Santa Fe machinist who lived in Coopertown. Several Winslow merchants donated the automobile as a community fundraiser.

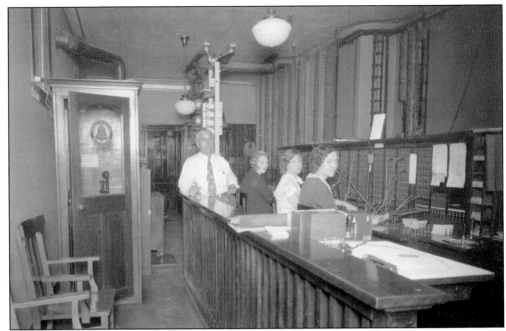

Winslow was granted its first telephone franchise in 1901. Flagstaff, Williams, and Winslow shared the phone directory, which listed the occupations of subscribers along with their names and addresses. In the 1940s, a new facility on Third Street and Kinsley Avenue replaced the 1930s office seen here.

Drs. Charles L. Hathaway and Ross Bazell, seen here around 1903, left the Santa Fe to open a private practice in this office on Kinsley Avenue and Third Street. Bazell later became one of the proprietors of Kelly Drug. Dr. Hathaway continued the practice, and seriously ill or hurt patients frequently recuperated in his spare bedroom. He often rode out to ranches when the owners or cowboys were too sick to come to town.

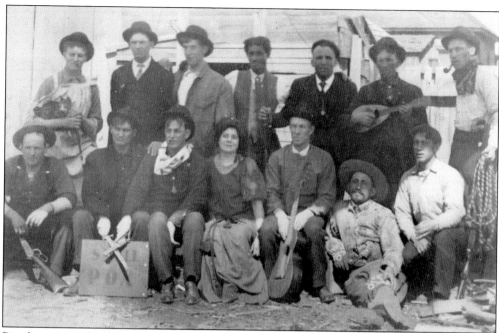

People suspected of having contagious diseases, such as German measles or scarlet fever, had to stay at a "pest house" until they got well or passed away. The city quarantined this group of residents suffering from smallpox at Mrs. Pillsbury's boarding house in 1907. When the 1918 flu pandemic hit, Dr. Hathaway examined as many homebound families as he could. Schools and other public places became hospital wards, staffed with local volunteers.

The Santa Fe medical offices were located in La Posada Hotel's west wing during the 1950s. Pictured here are, from left to right, Dr. Leo L. Lewis, unidentified, Dr. Harry S. Beckwith, division superintendent C.E. Rollins, and Santa Fe official J.N. Landreth. These Santa Fe physicians took care of employees and their families for many years.

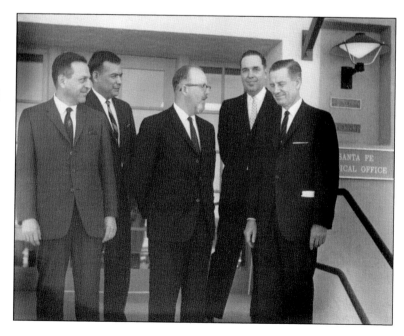

Winslow built its first permanent school structure in 1897, the same year the Santa Fe transferred divisional headquarters from Gallup. Seen here in 1916, Winslow Grammar School, located on West Oak Street, was later renamed Lincoln School. Contractor William A. Parr used locally quarried sandstone for the handsome structure, which boasted stained glass windows and a high bell tower.

Both designed by Los Angeles architect Lewis Wilson, the Froebel and Southside Schools opened in 1917. Originally named after the German "Father of Kindergarten," Froebel School was renamed Washington School in 1918 because of anti-German sentiment during World War I. Located on West Oak Street, the building was razed in the 1970s.

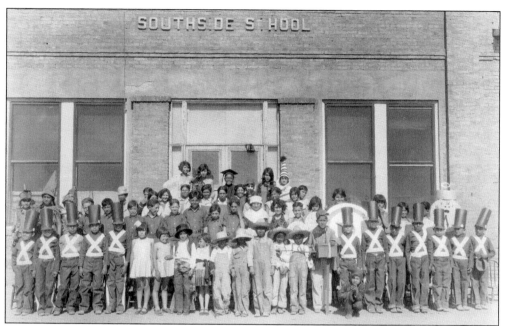

The Southside School on Washington Street served children living in Southside and Coopertown (seen here in costume for the 1929 production of the operetta *The Palace of Carelessness*). The school district changed the school's name to Roosevelt in 1935 in response to requests from the students. It closed in 1973 after a civil rights group took issue with its proximity to a sawmill, as well as the apparent segregation of the students. The building then served as Northland Pioneer College's first Winslow campus until 1985, when it was destroyed by fire.

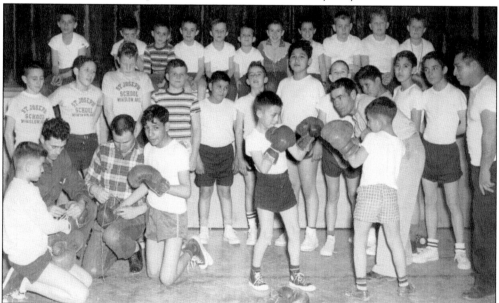

St. Joseph's School opened on West Hillview Street in 1951 and taught students from kindergarten through sixth grade. The school's Boxing Club received some expert coaching in 1954 from police officer Lorenzo Baca (kneeling in checkered shirt), who won a gold medal in boxing for the United States in the 1951 Pan-American Games. The church closed the school in 1977.

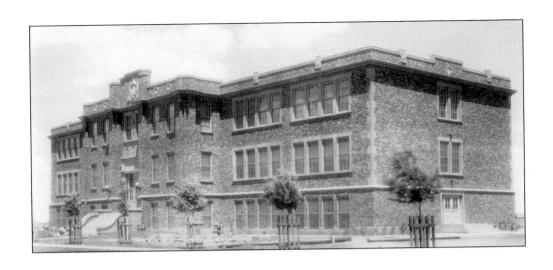

The 1912 Winslow High/Wilson School on East Maple Street was in disrepair by the late 1920s, so students petitioned door-to-door for funds for a new building. Above, the beautiful redbrick Winslow High School, designed by El Paso architects Trost & Trost, opened on Apache Avenue in 1929. Below, the graduating class of 1944 included salutatorian Marie Jane Madrid (first row, sixth from left) and valedictorian George Bertino (second row, fourth from left). Standing on the far right, sponsor Verla Oare graduated from the Wilson School in 1922, attended Teachers College in Flagstaff, and returned to teach government for 45 years at "Old Main." Some of her former students included US ambassador to Ghana William P. Mahoney (1934), US attorney general Richard G. Kleindienst (1941), and Ninth Circuit Court of Appeals judge Michael D. Hawkins (1963).

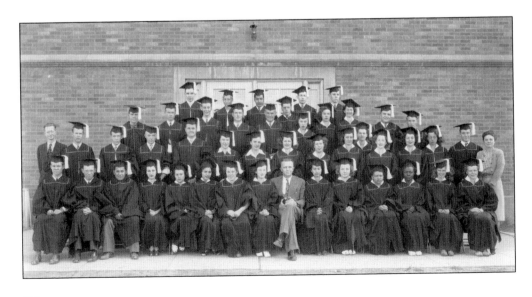

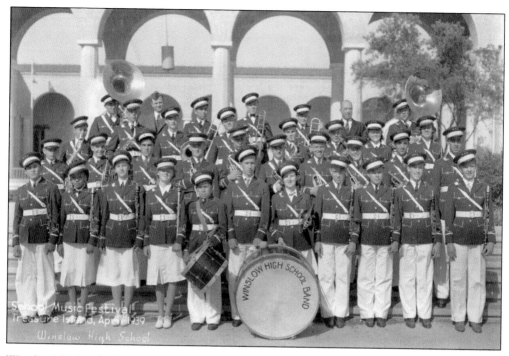

Winslow's high school had a band as early as 1918, and community fundraisers helped purchase uniforms and fund out-of-town travel. Above, the Winslow High School Band took part in the School Music Festival at the Golden Gate International Exposition on San Francisco's Treasure Island in 1939. Below, students working on the *Bulldog Barks* newspaper staff met with faculty member Estelee Hinson in 1953.

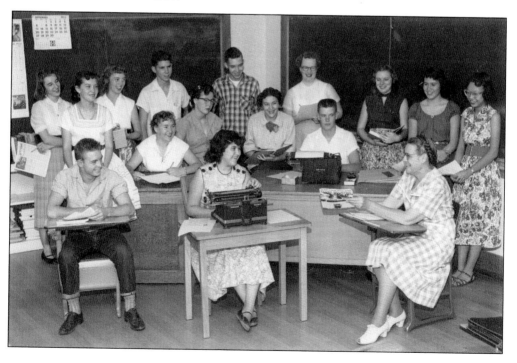

Winslow High School students engaged in a wide variety of social activities, such as this 1950s dance. Students also joined school organizations to pursue special interests, including acting, choral singing, photography, science, and Spanish language clubs.

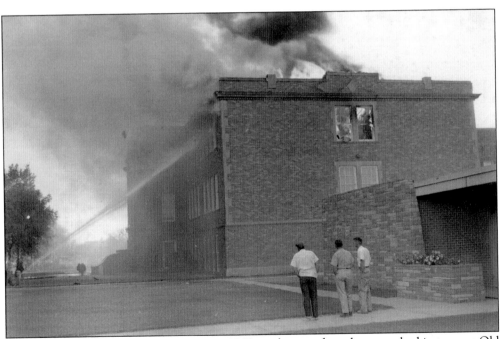

On the night before school was to start in 1960, students and teachers watched in tears as Old Main burned, set on fire by burglars who were never caught. The school board quickly made plans so that the class of 1961 could graduate on time, and the community helped ensure their success. Students attended classes in double shifts in the gymnasium and at Winslow Junior High, the Wilson School, the First Baptist Church, and in Holbrook until the building reopened in March 1961. The new Winslow High School opened in 2004, and the fate of Old Main is still in question.

Eight

COMMUNITY LIFE
RELIGIOUS, SERVICE,
AND CULTURAL ORGANIZATIONS

Community organizations gave the people of Winslow opportunities to bond with one another while they collectively worked to improve the lives of others. Aside from those discussed here, Winslow's religious denominations included Baptist, Jehovah's Witness, Lutheran, Nazarene, Pentecostal, and Presbyterian. Additional service and fraternal organizations included the International Order of Odd Fellows, Lion's Club, Rebekas, Soroptomists, Women's Benevolent Association, and the Winslow Women's Club.

As more women began to work outside the home before and after World War II, they organized for their mutual benefit. The National Federation of Business and Professional Women's Clubs was founded in 1919 and supported causes of working women, such as equal pay for equal work. Organized in 1939, the Winslow branch was active regionally as well as locally. Several Winslow women held statewide and district offices, and the branch hosted the state convention in 1952.

Mutual aid societies were important organizations in communities across the country, especially for minority ethnic groups. They provided food, clothing, and shelter to poor families; sponsored charitable fundraisers; offered sick benefits to workers excluded from labor unions; and supported civil rights. Winslow's most active society, la Comisión Honorífica Mexicana (Mexican Honorary Commission), was founded in the 1940s by the Mexican Consulate in Phoenix as a way for Mexican Americans to celebrate Mexican holidays and engage in social action in their communities.

The Santa Fe All-Indian Band was Winslow's most visible cultural organization. Though not the first all-Indian band in the region, this group formed in 1923 when three Native American musicians—Harold Youkti, Henry Whitmore, and John Outie—were conducted by Charles Erickson at a Santa Fe employee picnic. Navajos, Hopis, and Lagunas who worked for the railroad, as well as their family members, could participate. Later, Mexican American employees were also admitted. Dressed in colorful velvet shirts and Native American jewelry, the band played at hundreds of special events over their 41 years, including Winslow Christmas Parades, Arizona State Fairs, the San Diego Exposition, gubernatorial inaugurations, and President Eisenhower's inauguration parade in Washington, DC, in 1953.

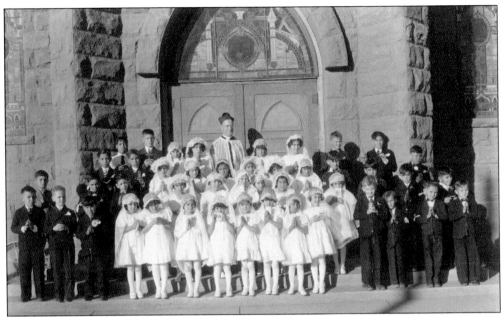

The Catholic Church was the first religious institution to take root in Winslow, building the original St. Joseph's Church on Front Street in 1892. These children, pictured above with Father Hootsman in front of the second St. Joseph's, celebrated their First Holy Communion around 1940. The redbrick structure with extensive stained glass was dedicated in 1923 at Second Street and Winslow Avenue. Fr. Eugene McCarthy opened both St. Joseph's School and Madre de Dios Church, the latter of which was dedicated in Coopertown in 1950. Fr. John Hannon, its first priest, oversaw the launch of a Madonna House Apostolate (a community of laity) and the construction of St. Francis Hall in Southside. He also introduced Winslowites to the Cursillo tradition, a Catholic movement involving three-day spiritual retreats like the one pictured below at St. Francis Hall around 1960. (Below, courtesy of Catherine Williams.)

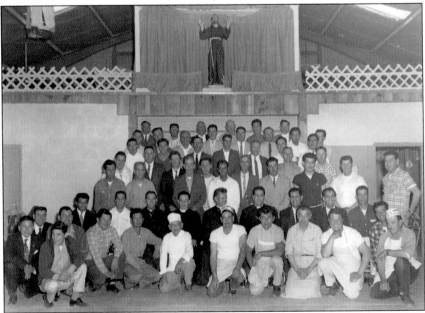

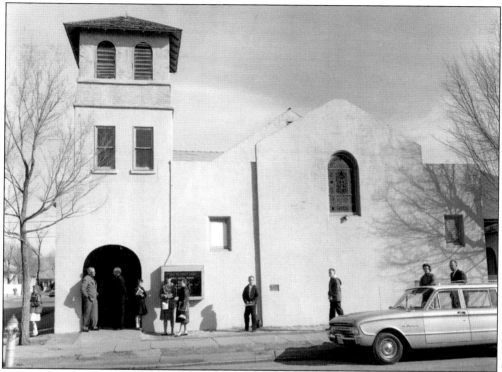

The First Episcopal Church was constructed east of St. Joseph's in 1892, and the First Methodist Church was dedicated on the corner of Second Street and Berry Avenue in 1893. Women helped finance these buildings by holding oyster stew suppers, dances, and ice-cream socials. This handsome structure on the corner of Third Street and Winslow Avenue opened in 1916 and served the Methodist congregation until they moved to their current location at Hillview Street and Kinsley Avenue in 1966.

The Mormons dedicated the first Winslow Ward Chapel of the Church of Jesus Christ of Latter Day Saints in 1930. The Berry Avenue building, shown here, served the Winslow Ward starting in 1951. A new Mormon church opened on West Lee Street in 1971. (Courtesy of Kaye Ricks.)

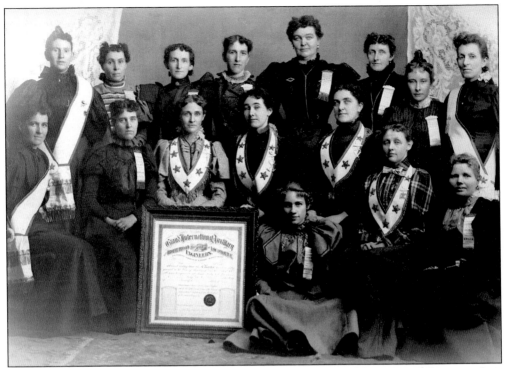

The wives of early railroaders missed their families back home, longed for trees and flowers in their red dirt yards, and spent long hours scrubbing overalls covered in railroad grease. Shown here with their charter, these women formed the Clear Creek Lodge of the Railroad Ladies Auxiliary on June 14, 1897. Among other activities, they organized grand balls for people throughout the territory.

Winslow's Masonic Lodge first met in 1896, and its sister organization, the Order of the Eastern Star, was formed in 1899. Eastern Star members, pictured here around 1910, gathered at the home of William (second from right) and Frona Parr (on William's right). Frona, who lived in this house on West Fourth Street for 70 years, also had a long association with the Methodist Church.

Arizona's Benevolent and Protective Order of Elks decided in 1912 to raise funds to reestablish Merriam elk in Arizona. Winslow Lodge No. 536 organized the details, and the herd arrived by train from Montana in early 1913. They are seen above resting in the Santa Fe stockyards before their release 50 miles south of town. Below, the *Elks Magazine* Studebaker Safety Tour stopped in front of Winslow's new lodge on West Third Street on its way from Chicago to the national convention in Denver in the 1940s. The lodge, which has an auditorium and kitchen, continues to host wedding receptions, class reunions, and other special events.

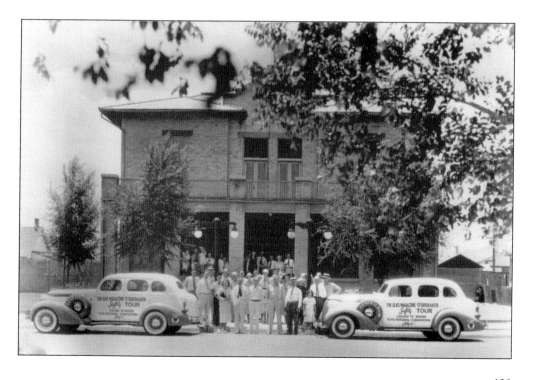

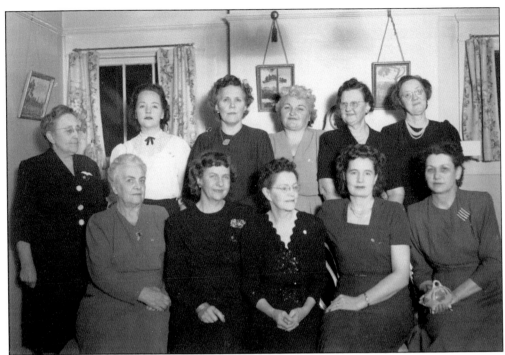

Pictured above in 1940, members of the Winslow Business and Professional Women's Club met at the home of Florence Beck Olmstead (first row, far right), who was elected their first president in 1939. The group was soon organizing fundraisers to support the country's World War II efforts. From the post-war years through the 1970s, Winslow's branch engaged in a range of civic and charitable activities, such as hosting get-out-the-vote events, awarding college scholarships, sponsoring students to Girls State, and entering floats in Winslow Christmas Parades. They also hosted social events, such as the 1950s tea pictured below.

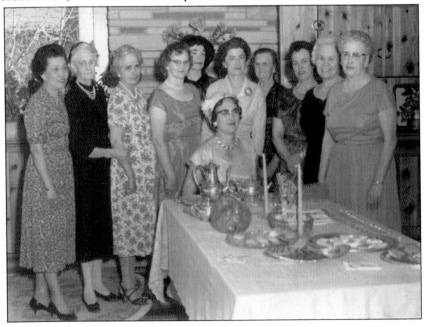

After La Posada Hotel closed in 1957, it sometimes functioned as a meeting place for local community groups. Here, the Winslow Rotary Club poses at the north-side entrance during a meeting in 1962. Former hotel manager Carl Weber is second from left in the first row.

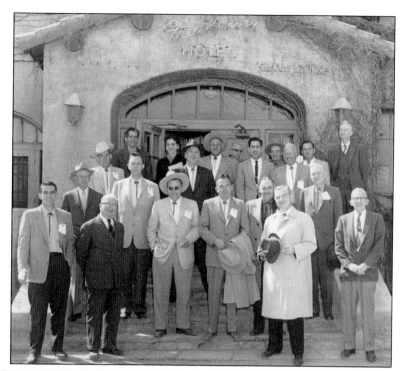

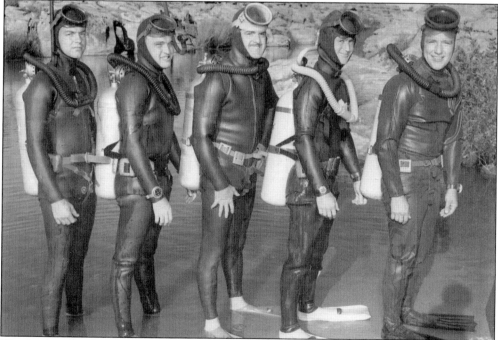

Winslow's scuba-diving club had fun but also participated in many rescues and recoveries at Clear Creek, just south of town. Pictured here in 1959 are, from left to right, Bill Emig, Bob Watmore, Harry Summers, Bill Carter, and Jack White. Watmore ran the control tower at the Winslow Airport, White was stationed at the radar base, and Summers worked for the Santa Fe and also took photographs for the chamber of commerce.

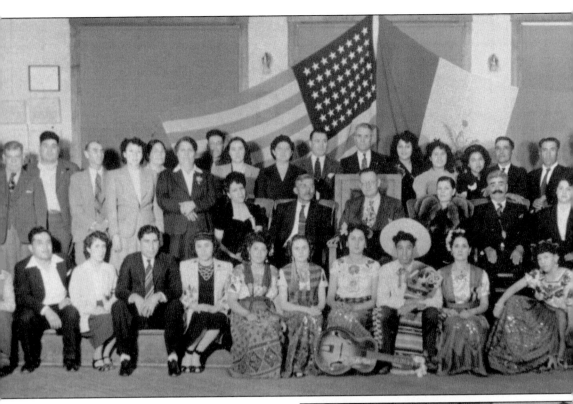

This 1947 photograph of Winslow's Comisión Honorífica Mexicana (La Comisión) shows one of the two major celebrations they organized each year for the local Mexican American community, el Cinco de Mayo (the Fifth of May) or el Dieciséis de Septiembre ("the Sixteenth of September," Mexican Independence Day). Free dances at the Arcadia Dance Hall, along with traditional music, costumes, and food, were important aspects of the festivals. Local businesses and Catholic organizations entered floats in a parade, and a Fiesta Queen was selected to lead it. La Comisión sponsored a social group for young women called the Girls' Rosebud Club, seen below in their finest dresses for a special event in 1954. (Below, courtesy of Vicki Espinosa Guardian.)

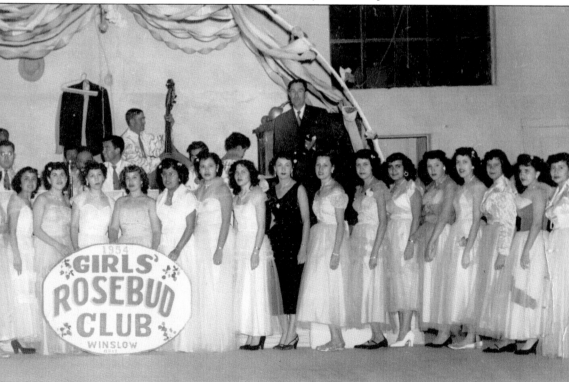

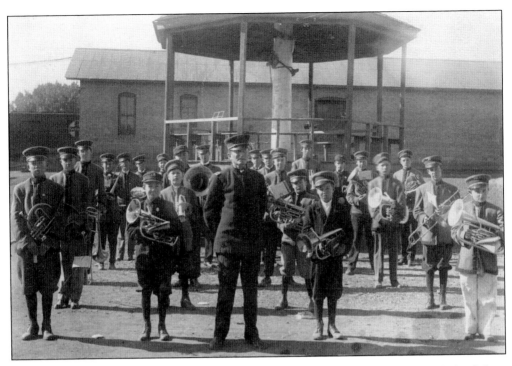

The Ellis Boys Band entertained the public in Winslow's early days, and townspeople helped them raise money for their instruments and uniforms. Seen above in 1912, they often held concerts in the gazebo at Front Street and Kinsley Avenue. Below, the Santa Fe All-Indian Band provided music for a flagpole dedication on La Posada's South Lawn in 1962. Felix Coin (far right) was the band's longtime director. Lacking new members, the band dissolved two years later.

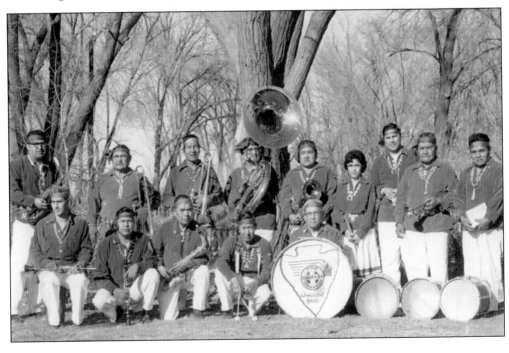

Nine

THAT'S ENTERTAINMENT
SPORTS, RECREATION, AND SPECIAL EVENTS

In Winslow's early days, simple pleasures included baseball games, picnics at Clear Creek, and dances with live music. Churches hosted ice cream socials and youth clubs. Santa Fe employees and their family members attended annual company picnics, participated in company-sponsored sports teams, and traveled on passenger trains with passes. During Route 66's heyday, residents enjoyed a wide variety of diversions, including live music venues and movie and drive-in theaters offering both English- and Spanish-language films. Some of the longstanding traditions continue, such as strong high school sports and Little League teams and the beloved Winslow Christmas Parade.

Tourist attractions are an important component of Winslow's current recreational life, and residents often revisit sites and events when hosting out-of-town guests. Route 66 received a historic highway designation in 1987, which encourages travelers to pull off and experience the charm and authenticity of small towns, like Winslow, along the route. Ever since the 1972 Eagles hit "Take It Easy" declared, "Well, I'm a standin' on a corner in Winslow, Arizona," travelers have also stopped to take photographs of corners around town. In 1999, the Standin' on the Corner Foundation dedicated a park of the same name at Route 66/Second Street and Kinsley Avenue. Ron Adamson's statue of a musician in front of John Pugh's two-story mural provides an ideal photo opportunity for fans of the song.

Locals and visitors alike enjoy the Standin' on the Corner Festival, the Material Girls Quilt Guild Show, and the Just Crusin' Car Club Show, all happening along Historic Route 66 each fall. Other attractions along the route include the Winslow Visitors Center/Hubbell Trading Post, the 9-11 Remembrance Garden, and La Posada Hotel. The hotel hosts over 80,000 visitors annually, including local and regional residents who come to attend special exhibits and programs at La Posada or to enjoy meals at the Turquoise Room. Visitors can also request tours of the hotel from the Winslow Harvey Girls, a group of volunteers who, since 1995, have dressed in the 1890s uniform and passed on the history of the Santa Fe and Fred Harvey. Both residents and tourists also enjoy nearby Homolovi State Park, as well as outdoor recreation in McHood Park at Clear Creek.

Above, the 1908 Winslow girls' basketball team played against Flagstaff, Holbrook, and Snowflake during their season. The new high school opened in 1912 and instituted its athletic program in 1915, with sports including football, basketball, baseball, and tennis. At left, the Winslow High School boys' basketball team had a winning record in 1924–1925. The players are, from left to right, (first row) William Murphy, Bill Pullins, and Oren Oare; (second row) Frank Brown, Glen Evans, Fred Chase (captain), James Schaar, and Murle Hohn. Coach Merwin Porter stands behind them. Many school athletic traditions began in the 1920s, including the designation of the bulldog as mascot and the annual football banquet.

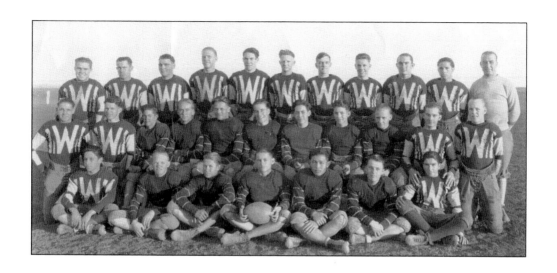

Above, Burrus Wilson (third row, far right) coached the Winslow High School football team during the 1930–1931 season, when they were Northern Arizona champions. Below, the Winslow High School baseball team is pictured in front of the new gym in 1949. In 1987, Winslow's football stadium was named after coach Emil Nasser (second row, far left). He was initiated into the National High School Coaches Hall of Fame in 1996.

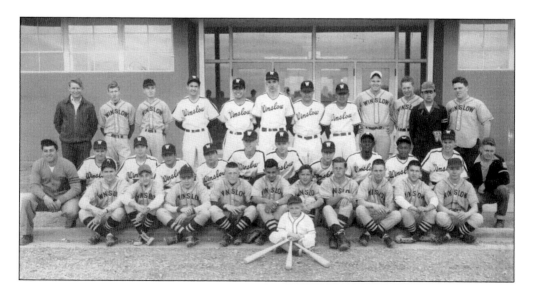

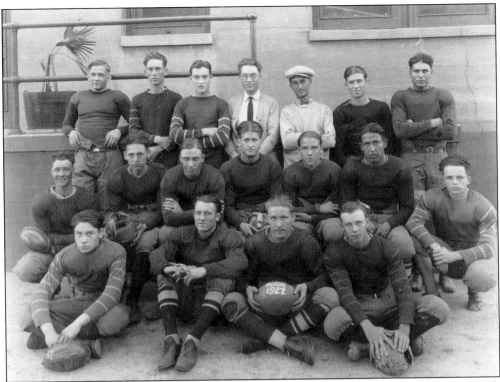

In Winslow's early days, railroaders formed football and baseball teams and created rivalries with other railroad towns like Ash Fork, Williams, Flagstaff, Holbrook, Gallup, and Albuquerque. Above is the Santa Fe Apprentice football team in 1928, and below is Winslow's Mexican baseball team, around 1905. In 1909, Santiago Baca's son Nestor pitched for the Winslow Reds, integrating the previously all-white team. (Below, courtesy of Dorothy Cooper Villanueva.)

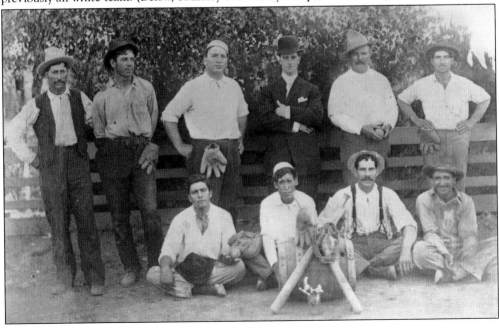

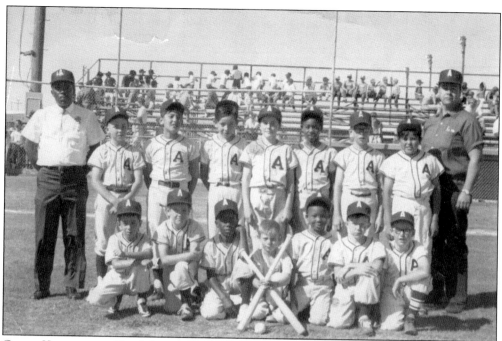

George Keaton started Little League for the youngest boys in 1951, and Bus Mead began the Babe Ruth league for the older boys in 1952. Above, coach Henry Lee Hayes (left), longtime Little League coach, AME minister, and president of the Winslow branch of the NAACP, is seen at Winslow Little League Park in 1969. Below is opening day at the park in 1953. (Above, courtesy of Mary Alice Hayes.)

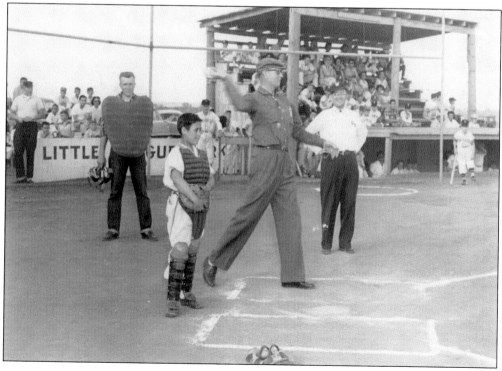

In this 1950s image, from left to right, Royal Smith, John Scott Sr., and an unidentified man watch Michael O'Haco Jr. take a swing at the Painted Desert Country Club north of town. The Winslow Country Club's clubhouse on Airport Road was constructed in the 1930s by the Works Progress Administration (WPA). Neither course survived.

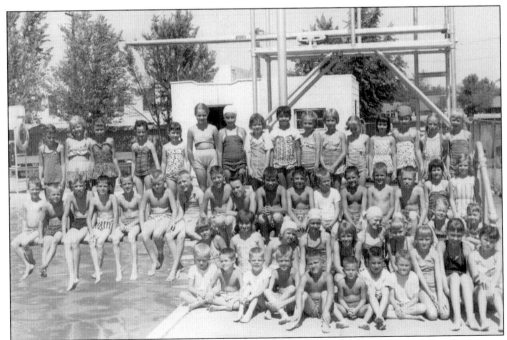

Also constructed by the WPA, the Winslow Municipal Pool at Maple Street and Colorado Avenue was as busy in the 1950s as it is today. In 1955, the Alianza Hispano-Americana filed a lawsuit challenging the pool's racially discriminatory practices. *Baca v. Winslow* prompted the city to change its policies without the case reaching the courtroom.

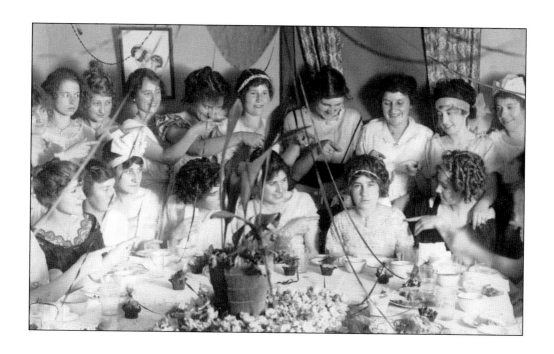

Weddings were important religious and social events in early Winslow. Above, the lavish table decorations at Irene Dadey's bridal shower in 1915 were probably ordered by mail-order catalog. Below, this large Mexican American wedding, around 1925, was likely performed during High Mass at St. Joseph's Church. It was customary for the bridal couple's godparents to lead La Gran Marcha, or "the Grand March," which ended with La Entregada, the formal giving of the bride to the groom. The evening would have ended with a dinner and festive wedding dance with live music. (Below, courtesy of Ernest Martinez.)

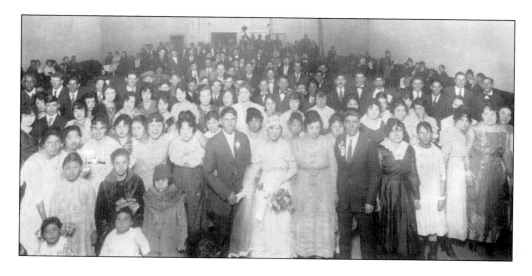

Leorena Shipley, a nationally recognized stage actress under the stage name "Norma Deane," returned to Winslow to visit her parents, Maj. Leo and Della Shipley, in 1926. Leo was a railroad official who served in France during World War I, and Della was a musician and artist. Leorena was returning from the Petrified Forest when her automobile got stuck in a flash flood in Cottonwood Wash just east of town. She drowned at the age of 29.

Pharmacist Welton Hughes (right) shakes the hand of cowboy-actor Buck Jones outside the drugstore on the northeast corner of Route 66/Second Street and Kinsley Avenue. A poster advertising the movie *Seventh Heaven*, starring James Stewart, dates this image to 1937. The Rialto Theatre, which opened downtown in 1927 with opera chairs and an air conditioning system, began showing talkies for 10¢ admission in 1929.

In 1957, Betty Patterson was named Mrs. Arizona and first runner-up to Mrs. America. She and husband E.J. Patterson appeared on Perry Como's nationally televised show in New York City and presented him with a Hopi kachina on behalf of the people of Arizona. Patterson was a driving force behind local historic preservation projects including the Old Trails Museum, Hubbell Trading Post, and La Posada Hotel. (Courtesy of Janice Patterson Griffith.)

Tommy Dukes (left) and David Chavez Sr. hold each other's first guitars in 1957. Dukes relocated to Winslow from Mississippi at age 10. His professional career began just five years later and has resulted in many original songs, several album recordings, and his induction into the Arizona Blues Hall of Fame in 1997. (Courtesy of Tommy Dukes.)

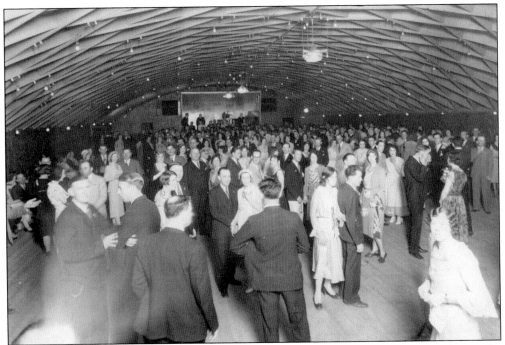

Dances were held most Saturday nights at the Arcadia Dance Hall on First Street during the 1920s and 1930s. This building now houses the Desert Scene Lodge No. 1267, the local branch of the Improved Benevolent Protective Order of the Elks of the World, or Black Elks. The African American fraternal organization has a long history of hosting youth dances, Juneteenth celebrations, and other special events, including a 1966 performance by the Jackson Five.

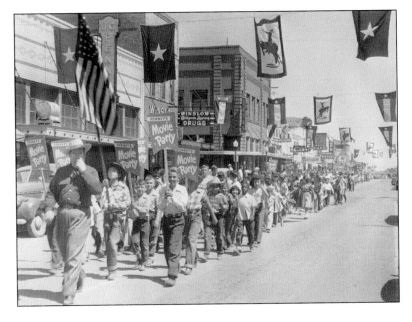

J.C. Penney threw a movie party for Winslow's youth in the 1950s. Party attendees marched down Route 66/Second Street during a rodeo parade in anticipation of the event.

Winslow hosted Indian Day for many years, which in 1955 was held on the west grounds of La Posada Hotel and attended by almost 4,000 Navajos and Hopis. The Winslow Women's Club served hot dogs and soda pop, and Santa Claus handed out toys to over 2,000 children. Many Route 66 travelers also stopped to enjoy the bands, dancers, and speakers.

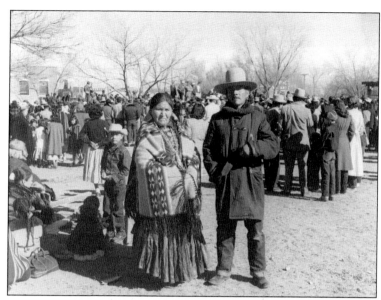

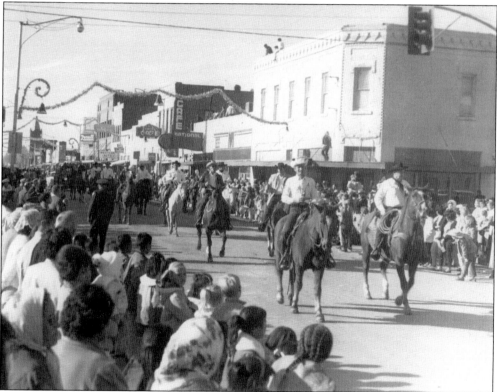

After World War II, Winslow's Retail Trade Committee hoped to stimulate economic prosperity by encouraging citizens to do their Christmas shopping locally. They started a new tradition in 1946, the annual Winslow Christmas Parade, which continues to kick off the holiday season each year on the Saturday before Thanksgiving. The parade features floats, Native American bands and dancers, and equestrian units like the one seen here in the 1950s. (Courtesy of the Rhoton family.)

Above, the Church of Jesus Christ of Latter Day Saints entered this float in the 1964 Christmas parade. From left to right are Christina Richards, Susan Sorenson, Debbie Stout, and Marsha Orvin. Below, the Santa Fe float in the 1954 parade showed off a scale model of their new diesel passenger locomotive painted in red, gold, and silver. Here it is crossing the intersection of Route 66/Second Street and Williamson Avenue. Now a project of the Winslow Chamber of Commerce, the annual Winslow Christmas Parade is one of the oldest and largest in Arizona. Hundreds of Navajos and Hopis come early each year and sell jewelry, crafts, and food along Historic Route 66 before the parade starts.

About the Organization

Located in the heart of Winslow's downtown business district, the Old Trails Museum is just across the street from the Standin' on the Corner Park at the intersection of Historic Route 66/ Second Street and Kinsley Avenue.

Western Savings and Loan donated the 1921 First National Bank building to the Winslow Historical Society in 1985, and after four years of building improvements and donations from former and current residents, the Old Trails Museum held its grand opening on July 8, 1989.

A dedicated group of museum directors, board members, and volunteers has continued to improve the historic building, collect and preserve information and artifacts representing the history and cultures of the Winslow area, and develop exhibits and programs that engage and enlighten visitors to the Old Trails Museum.

The Old Trails Museum is owned and operated by the Winslow Historical Society, a 501(c)(3) nonprofit corporation funded by the City of Winslow, memberships, donations, and sales.

Visit www.oldtrailsmuseum.org for more information.

DISCOVER THOUSANDS OF LOCAL HISTORY BOOKS
FEATURING MILLIONS OF VINTAGE IMAGES

Arcadia Publishing, the leading local history publisher in the United States, is committed to making history accessible and meaningful through publishing books that celebrate and preserve the heritage of America's people and places.

Find more books like this at
www.arcadiapublishing.com

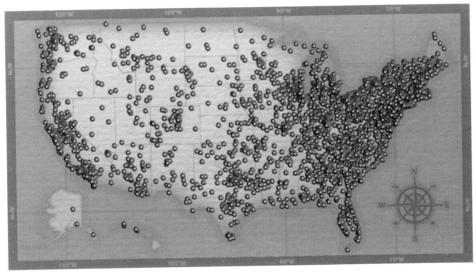

Search for your hometown history, your old stomping grounds, and even your favorite sports team.